to _____

from _____

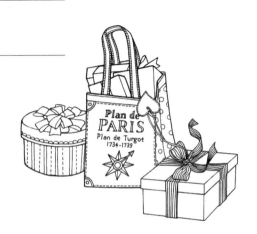

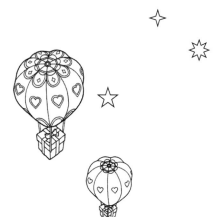

Published in the United States by Watson-Guptill
Publications, an imprint of the Crown Publishing
Group, a division of Penguin Random House LLC,
New York.
www.crownpublishing.com
www.watsonguptill.com

WATSON-GUPTILL and the WG and Horse designs are
registered trademarks of Penguin Random House LLC.

Originally published in Korea as *The Present* by The
Angle Books Co., Ltd., Seoul, in 2015. All rights
reserved. English language rights arranged with
The Angle Books Co., Ltd., care of The Danny Hong
Agency, Seoul, through Gudovitz & Company
Literary Agency, New York.

Trade Paperback ISBN: 978-0-399-57904-2

Printed in China

Design by Tatiana Pavlova

10 9 8 7 6 5 4 3 2 1

First American Edition

the night voyage

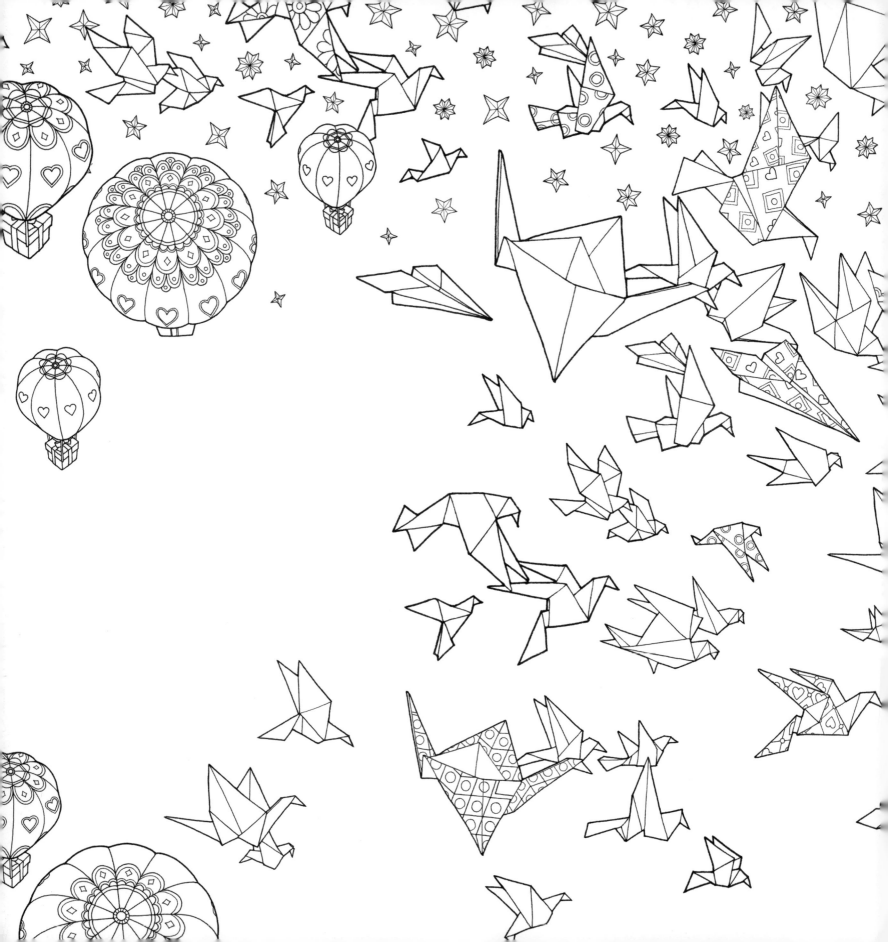

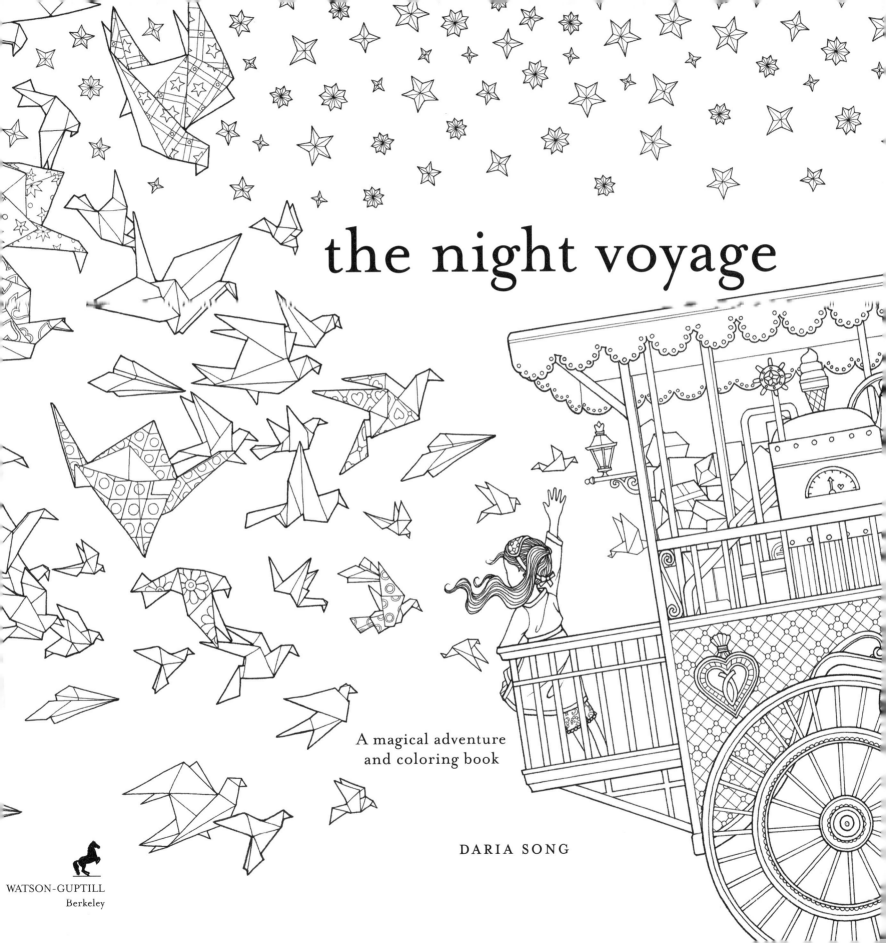

the night voyage

A magical adventure
and coloring book

DARIA SONG

WATSON-GUPTILL
Berkeley

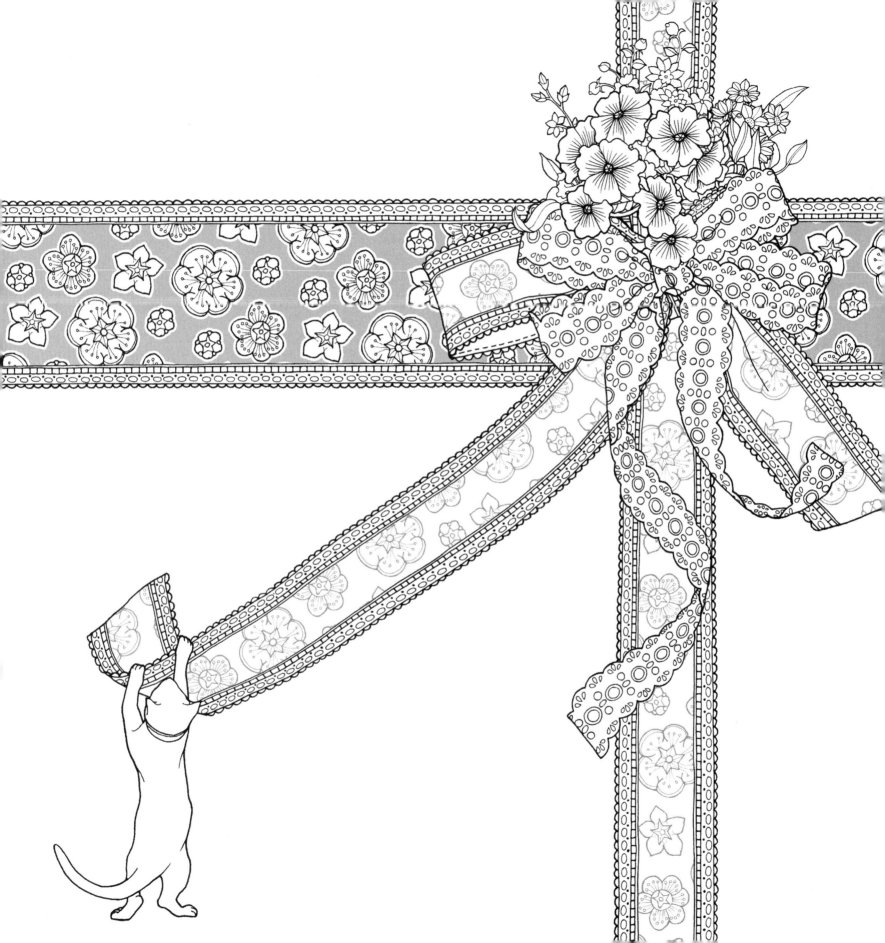

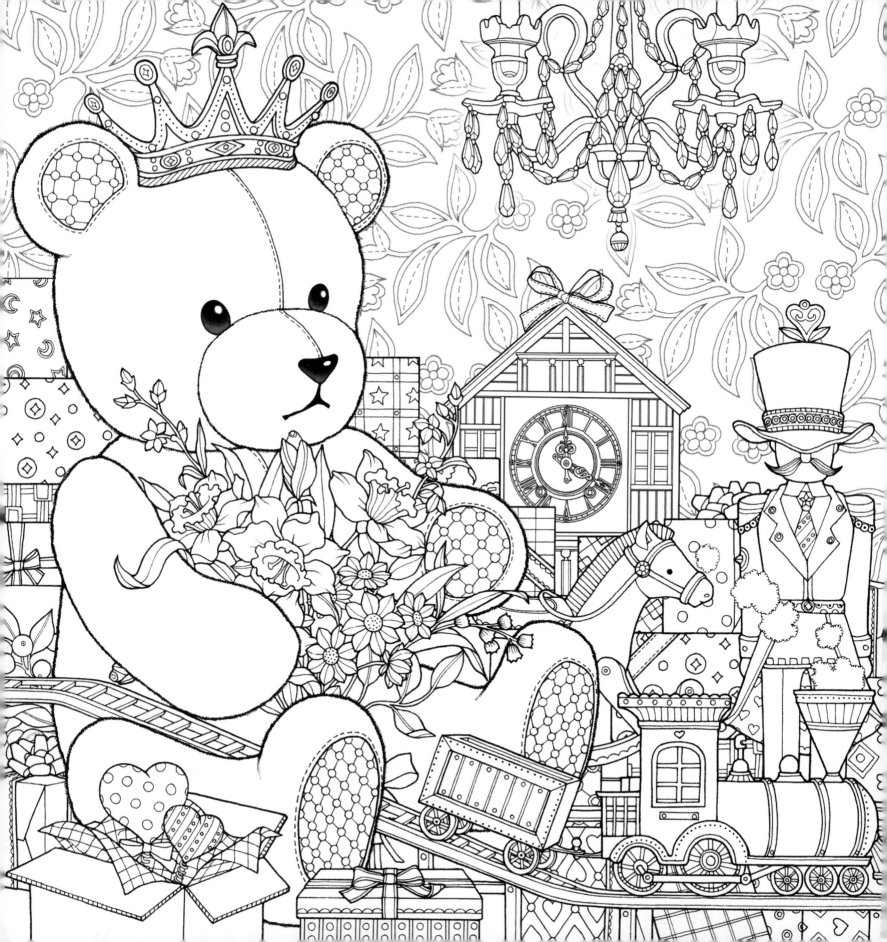

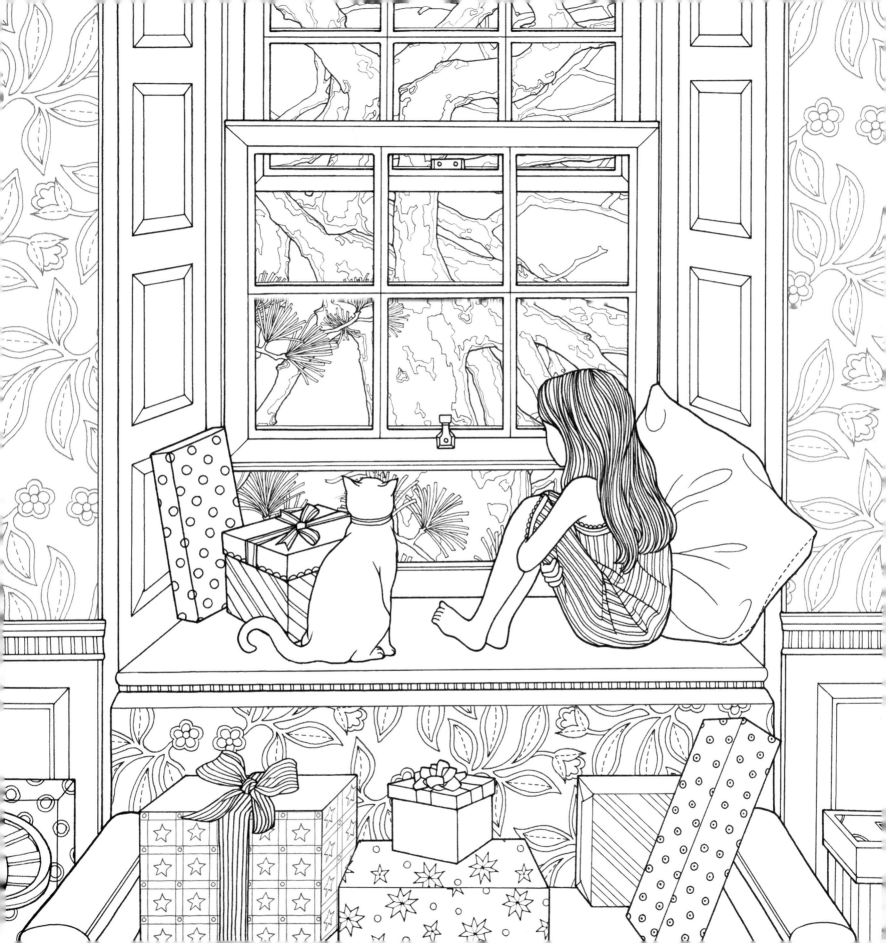

The little girl's birthday was tomorrow, and she was
surrounded by presents.

"Sorry we have to be away for a business trip on your birthday,"
her parents had told her. "But we left a mountain of gifts for you
to unwrap and play with!"

Yet even though the little girl was surrounded by colorfully wrapped
boxes, folded paper cranes, her model train set and toy conductor,
and her cat Phoebe, she felt lonely. She looked out her window
at the tree standing alone outside.

Suddenly, she had an idea. She said to Phoebe, "I bet if I take these
presents and give them to all the other girls and boys around the world,
I'll make some new friends! But how would I get them out . . ."

The cuckoo clock in her bedroom struck midnight.
She must have dozed off.

What was happening in her room? A mass of shiny little stars
danced outside her window.

"Ding, ding." As she rubbed her eyes in surprise, little stars scattered
to the sound of a bicycle bell from far away. Suddenly, a familiar face
appeared: it was her toy conductor, now life-size. "All aboard!" he cried.
"I am here to help you distribute your presents across the world.
And at the end of the night, you will get the best present of all."

With a flock of paper cranes to help, he loaded her presents up,
and away they went on a grand adventure.

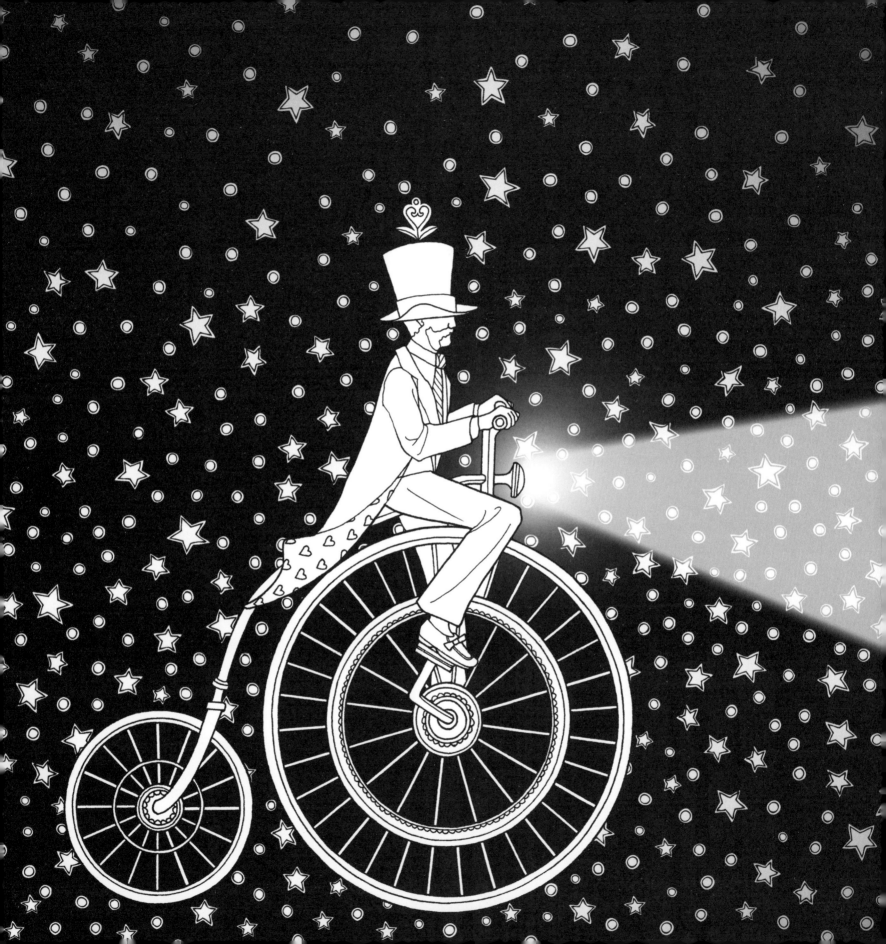

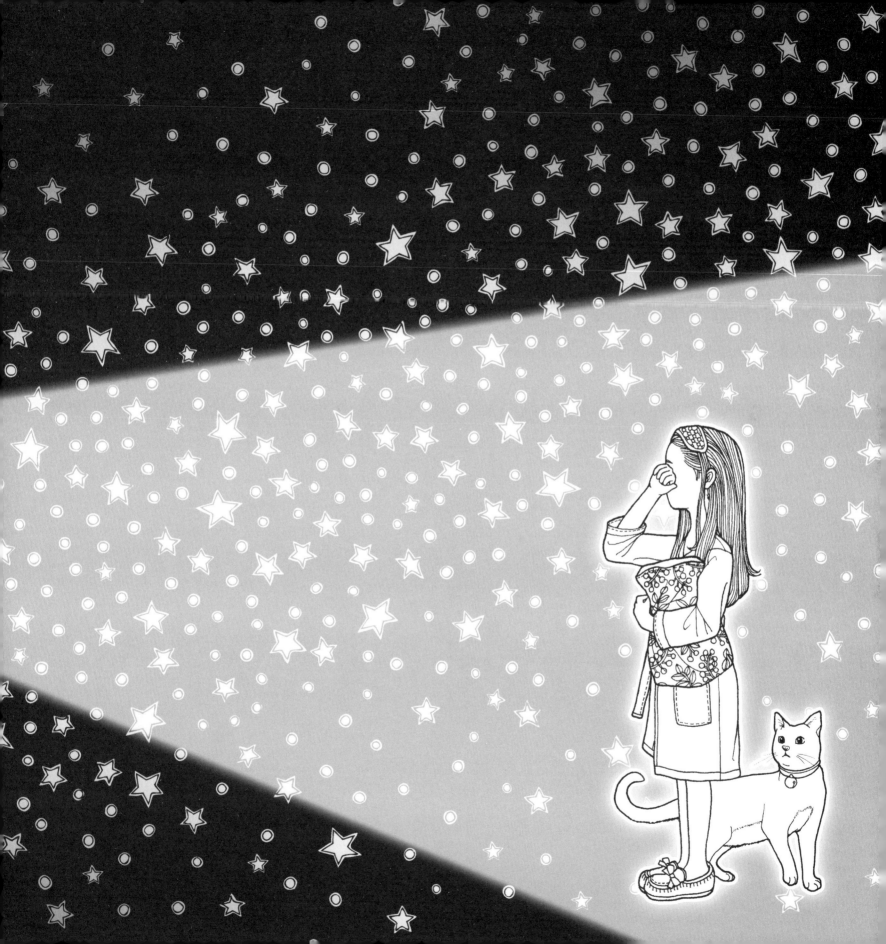

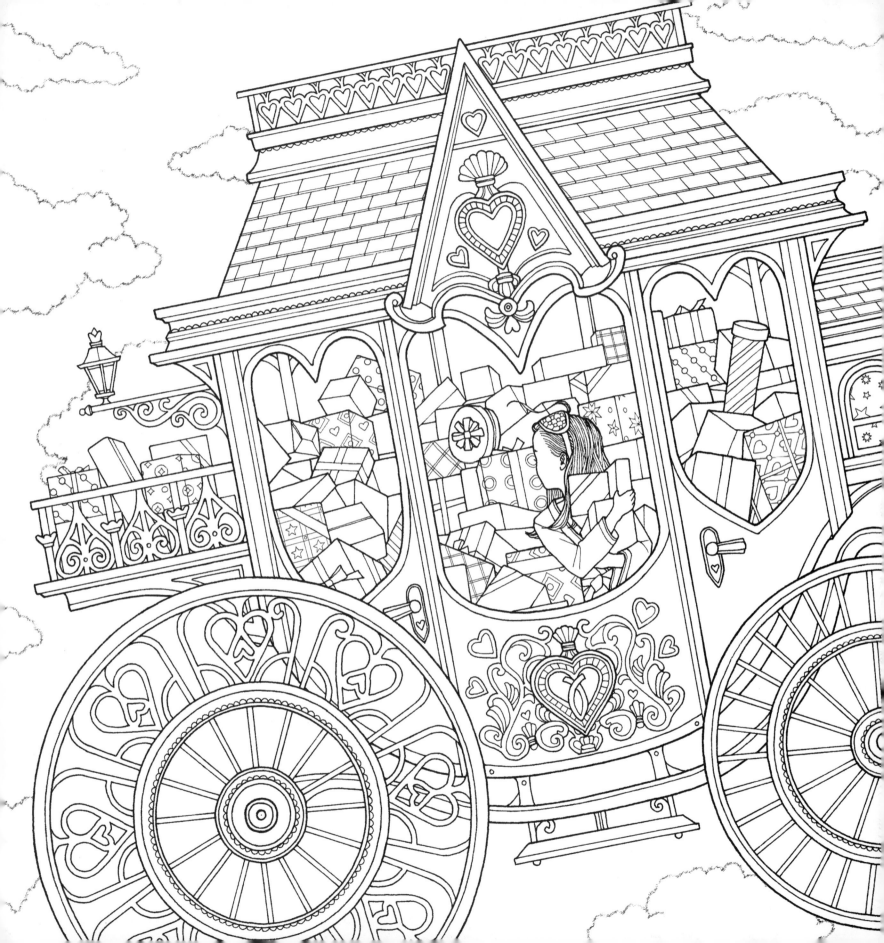

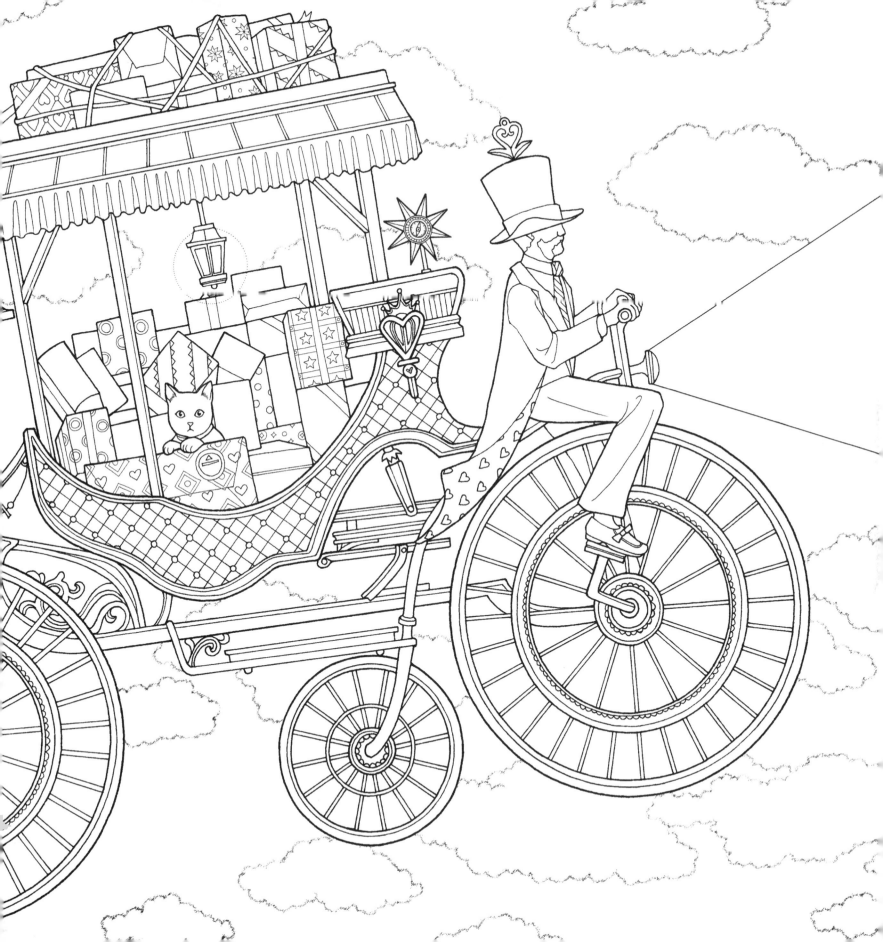

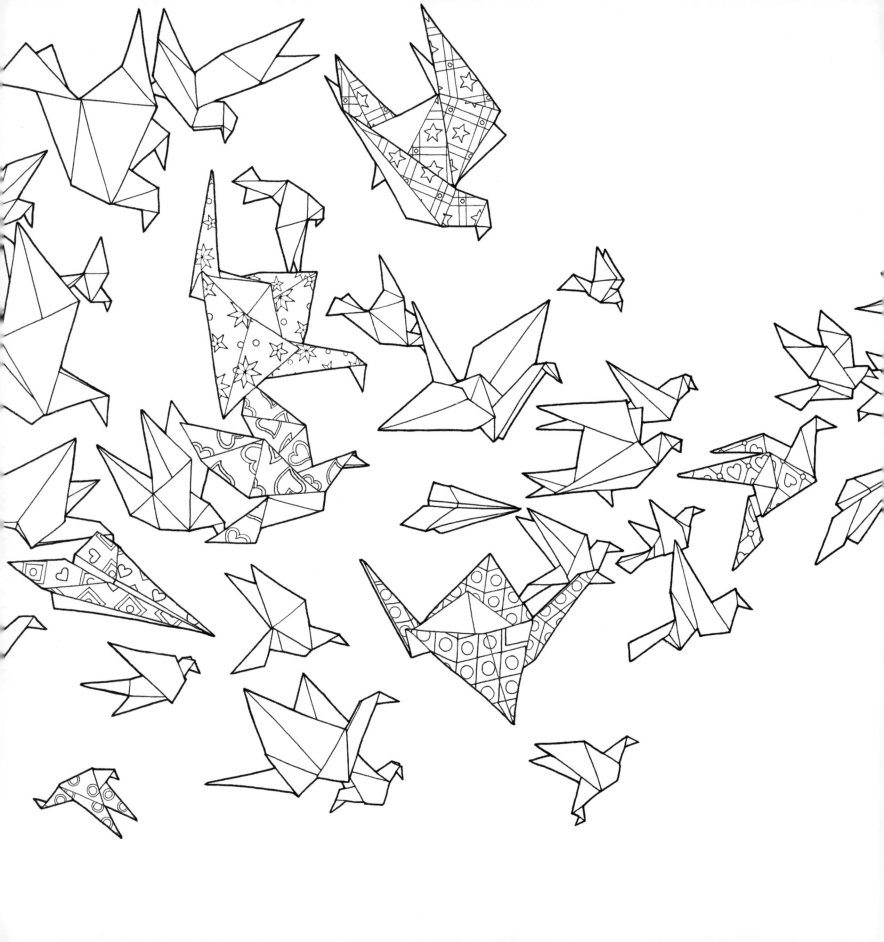

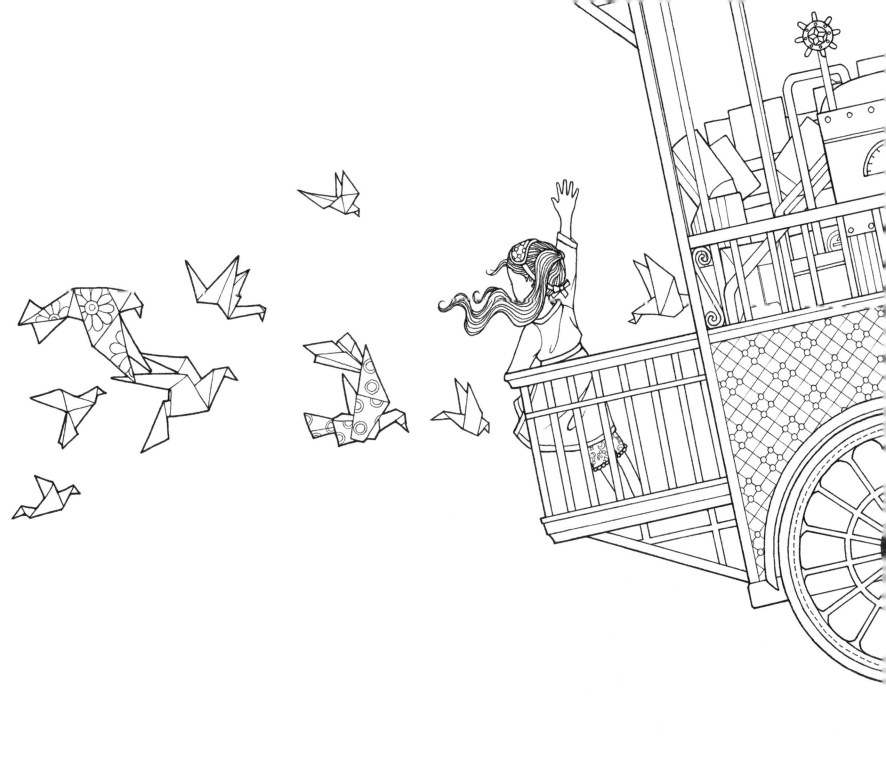

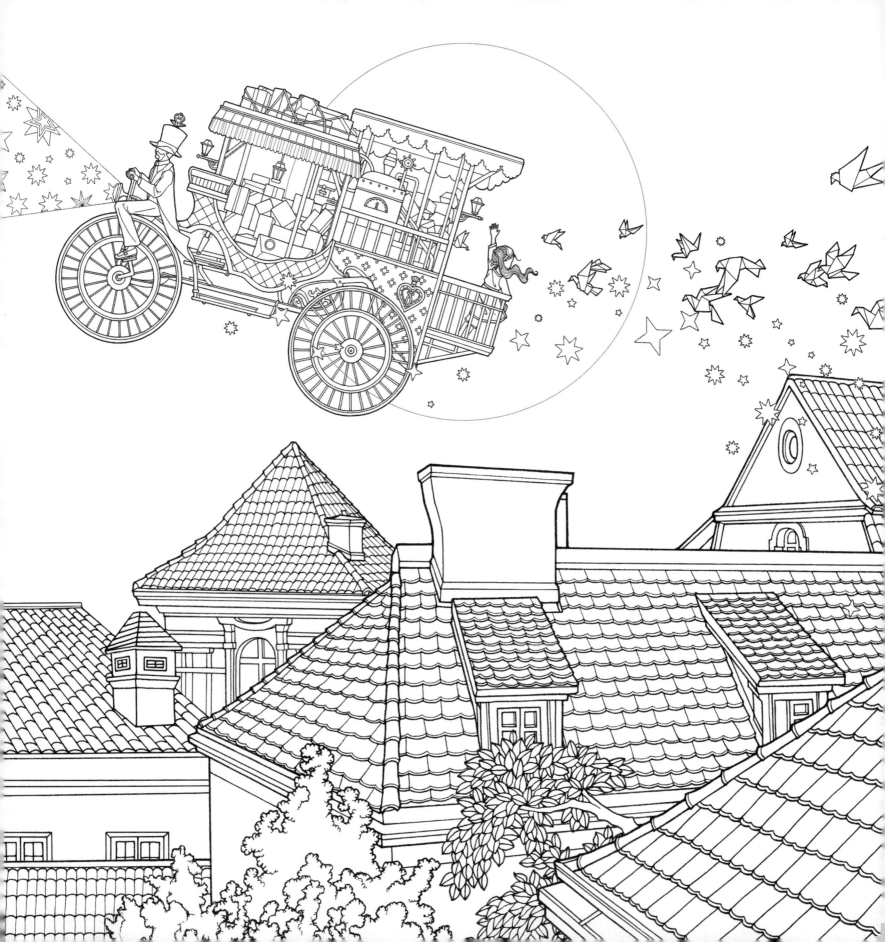

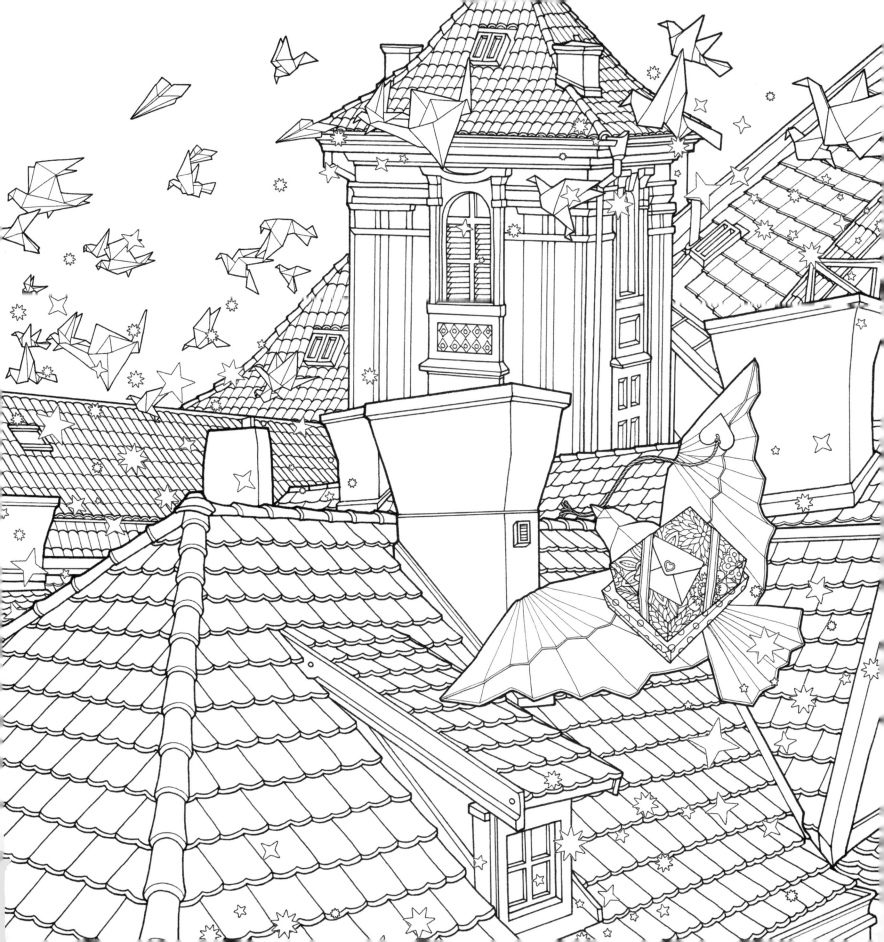

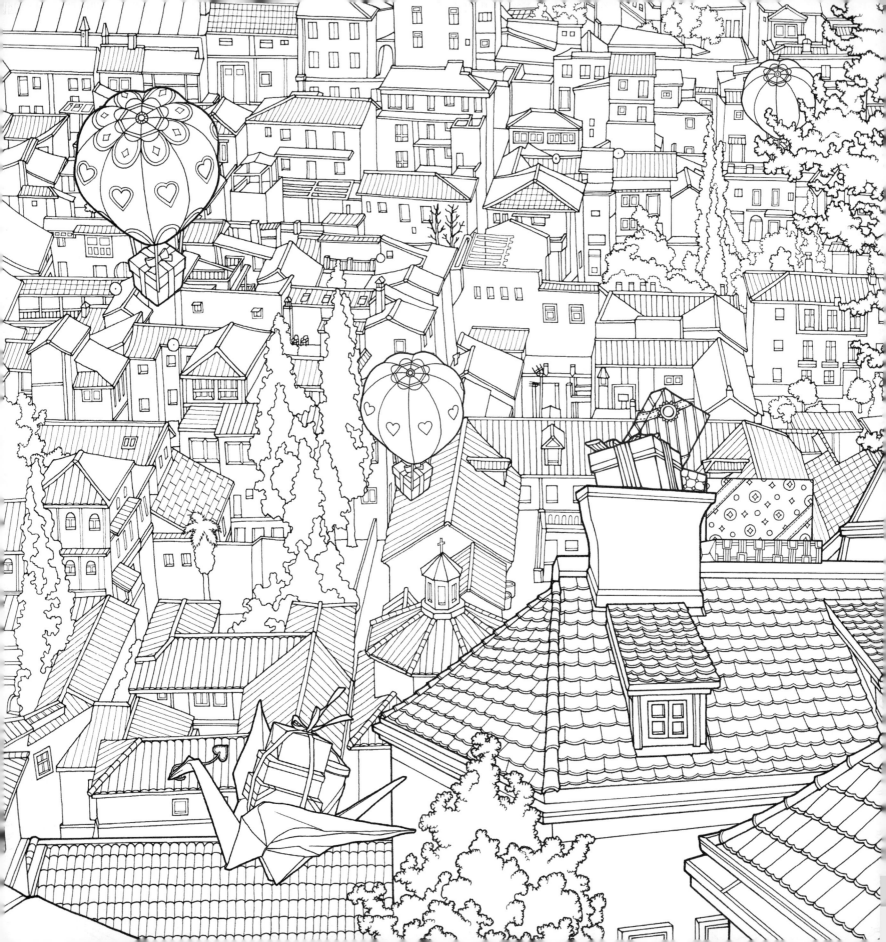

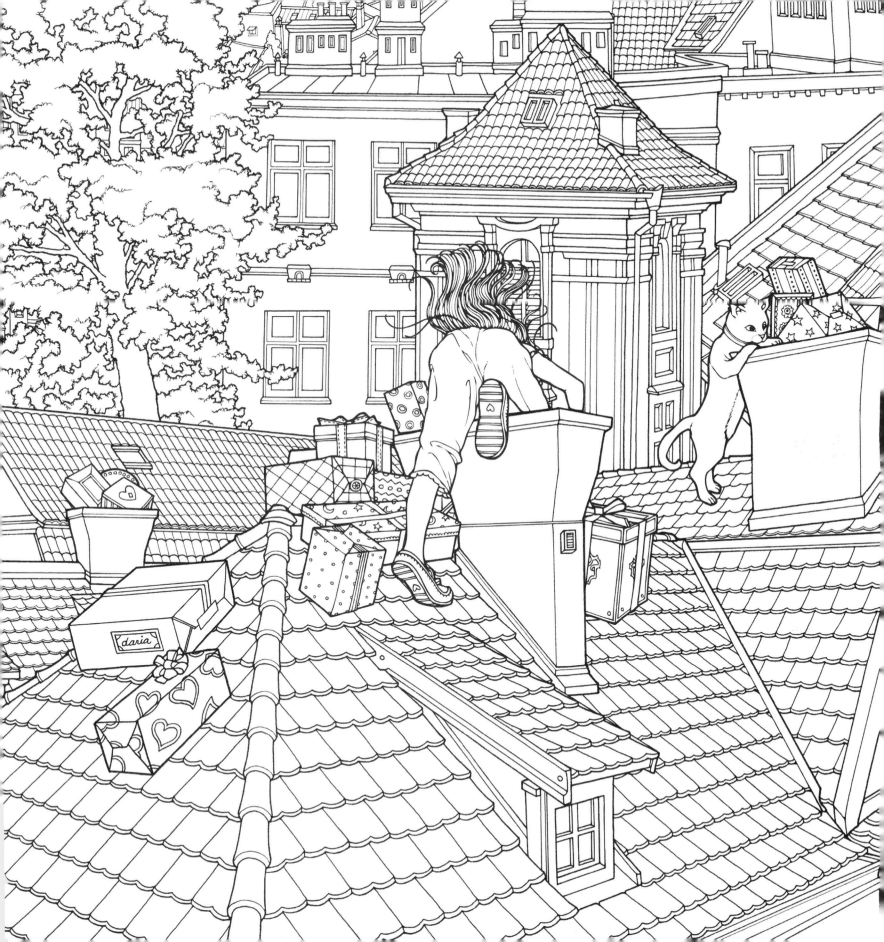

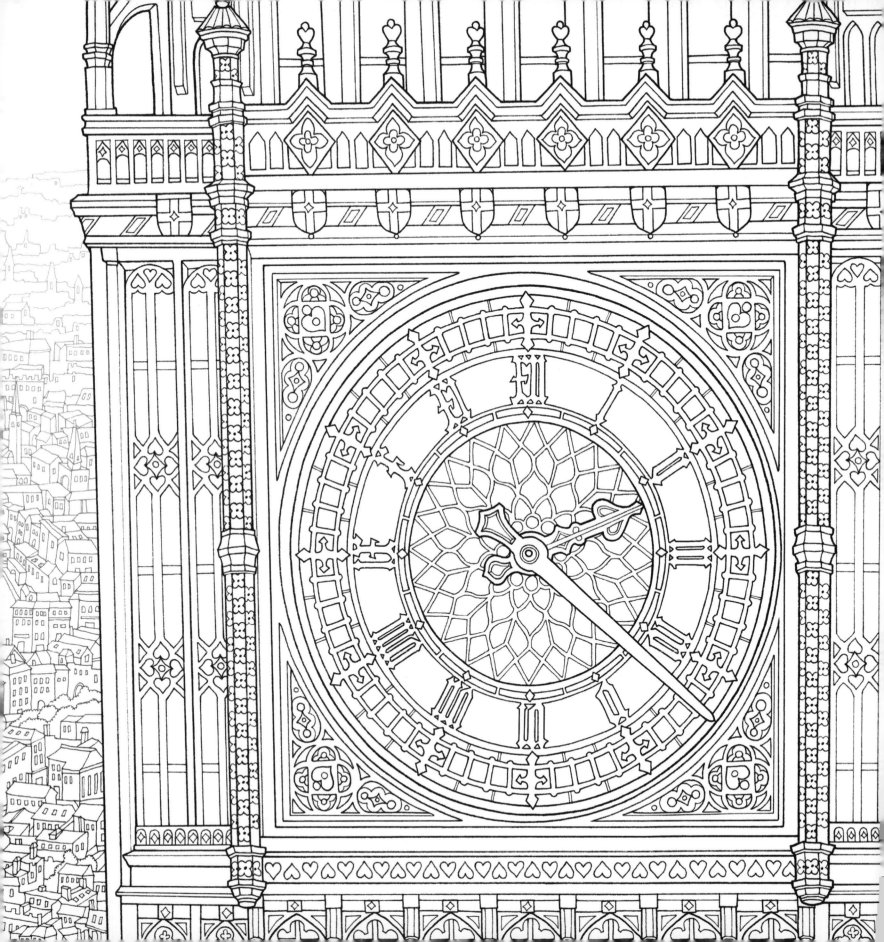

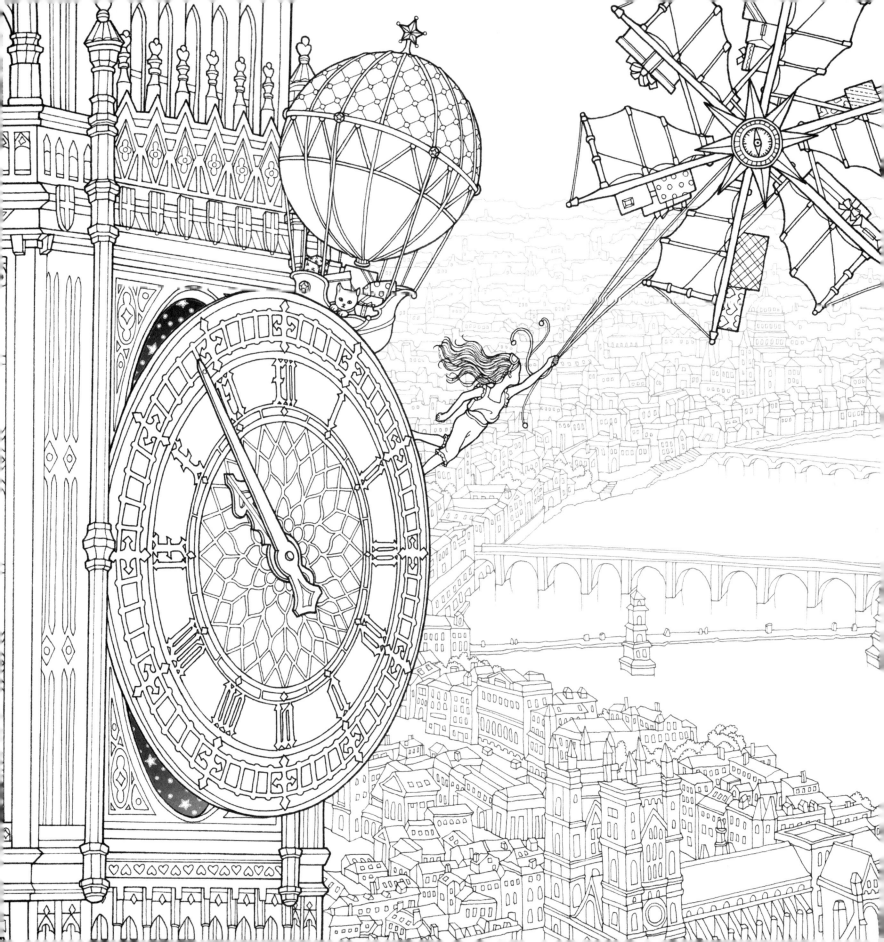

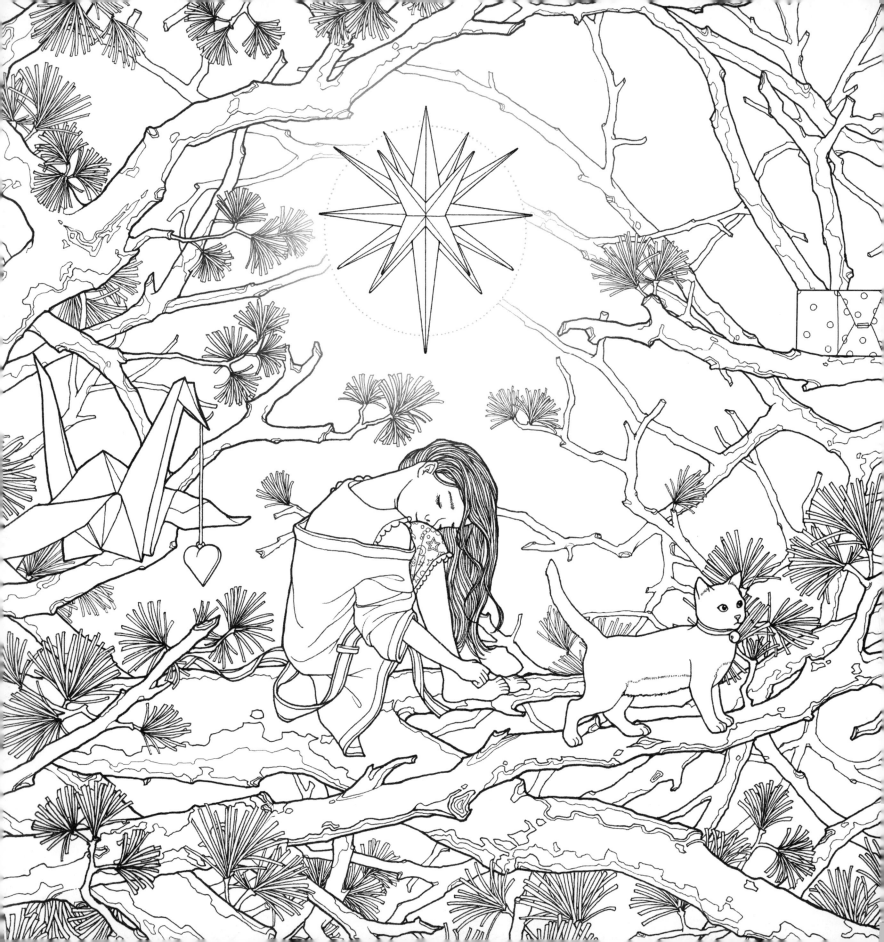

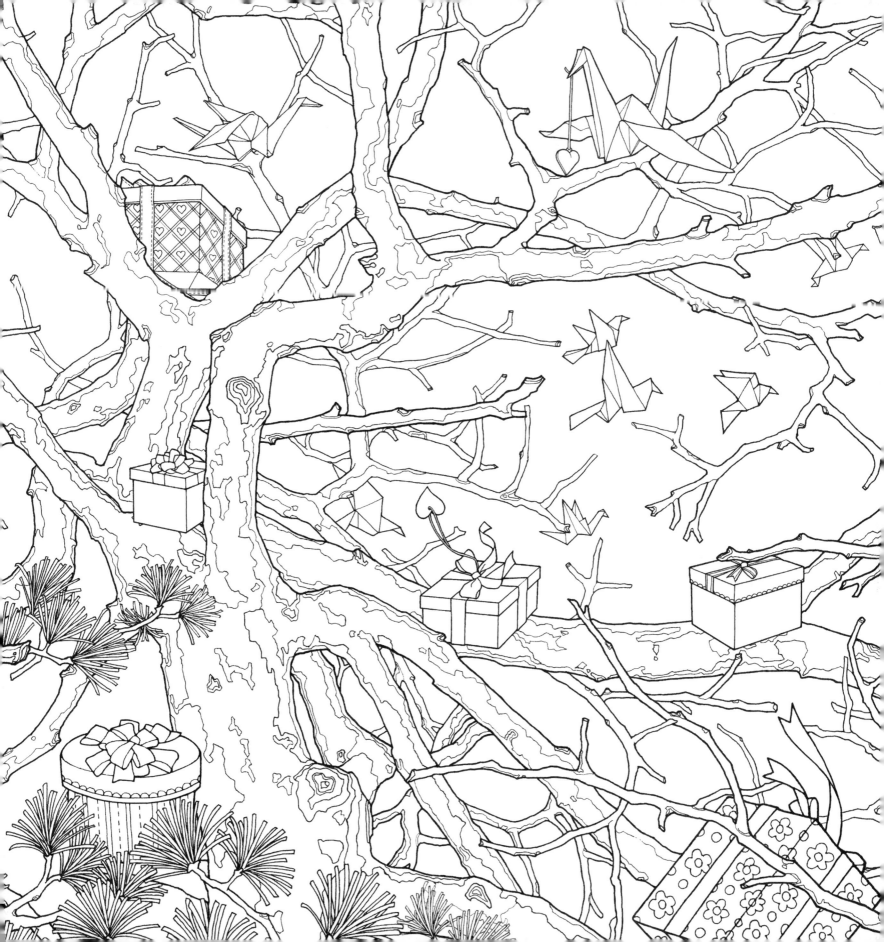

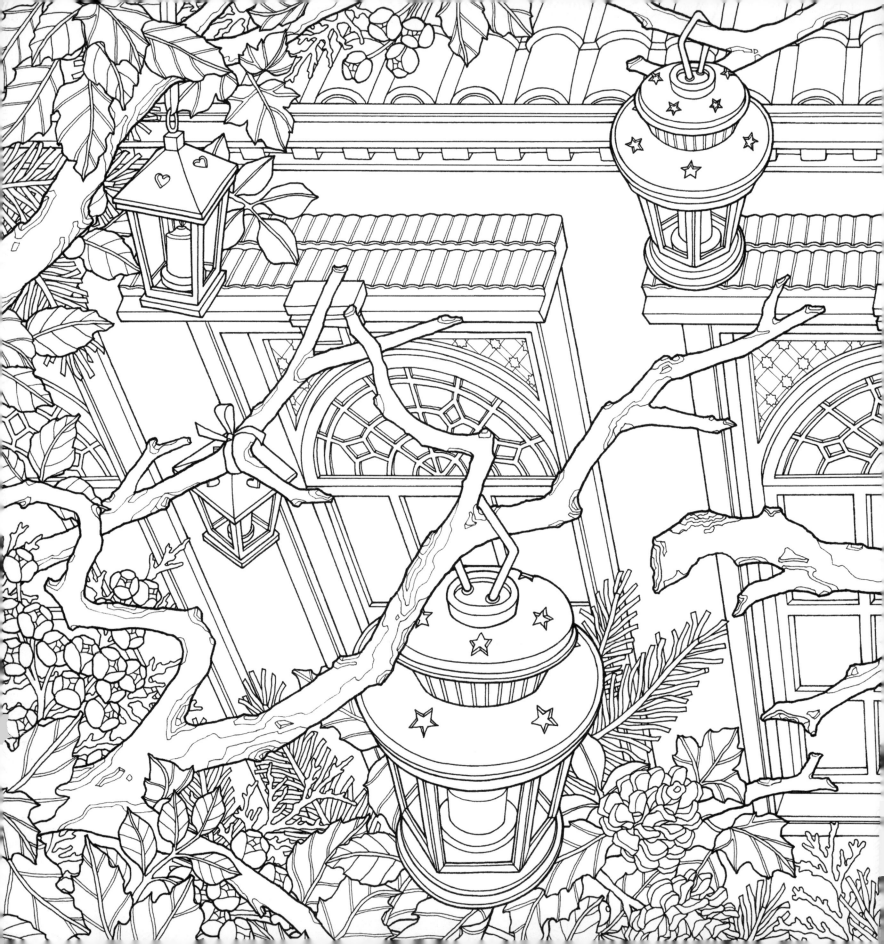

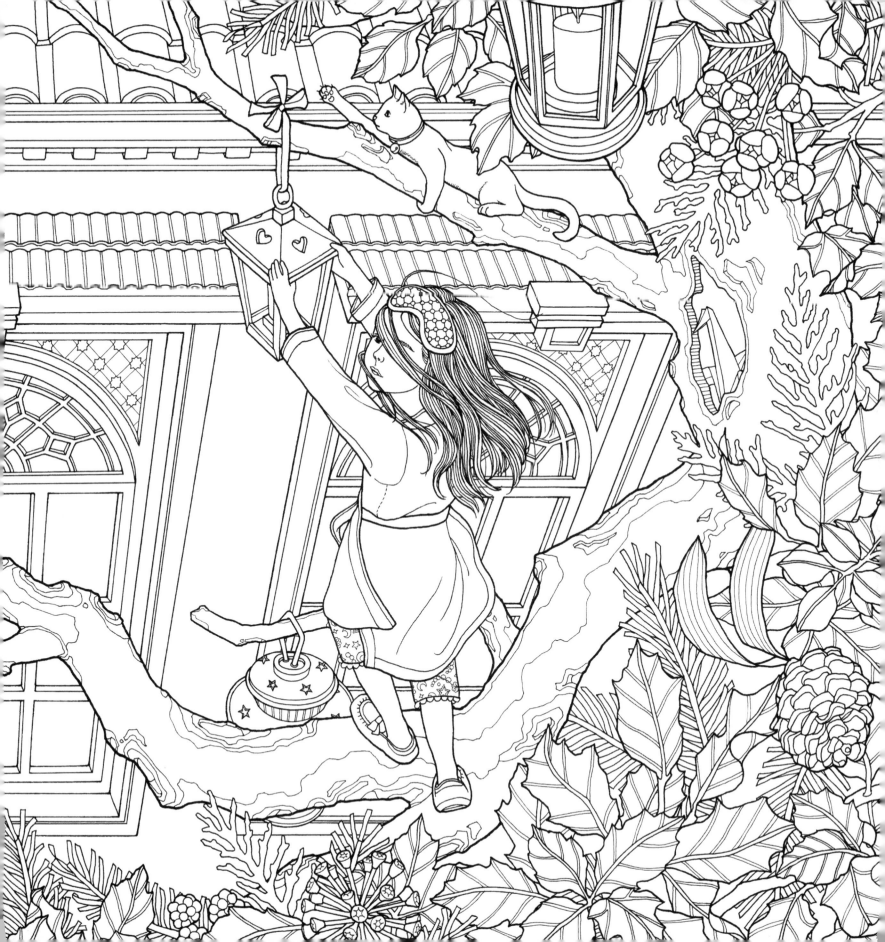

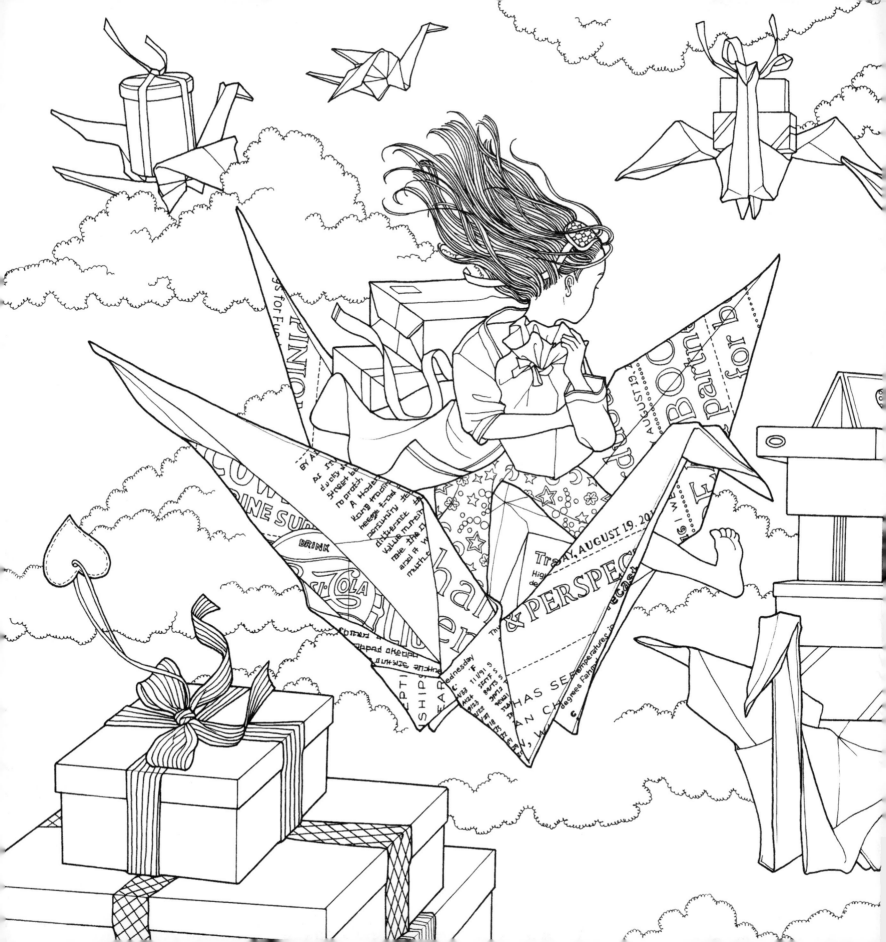

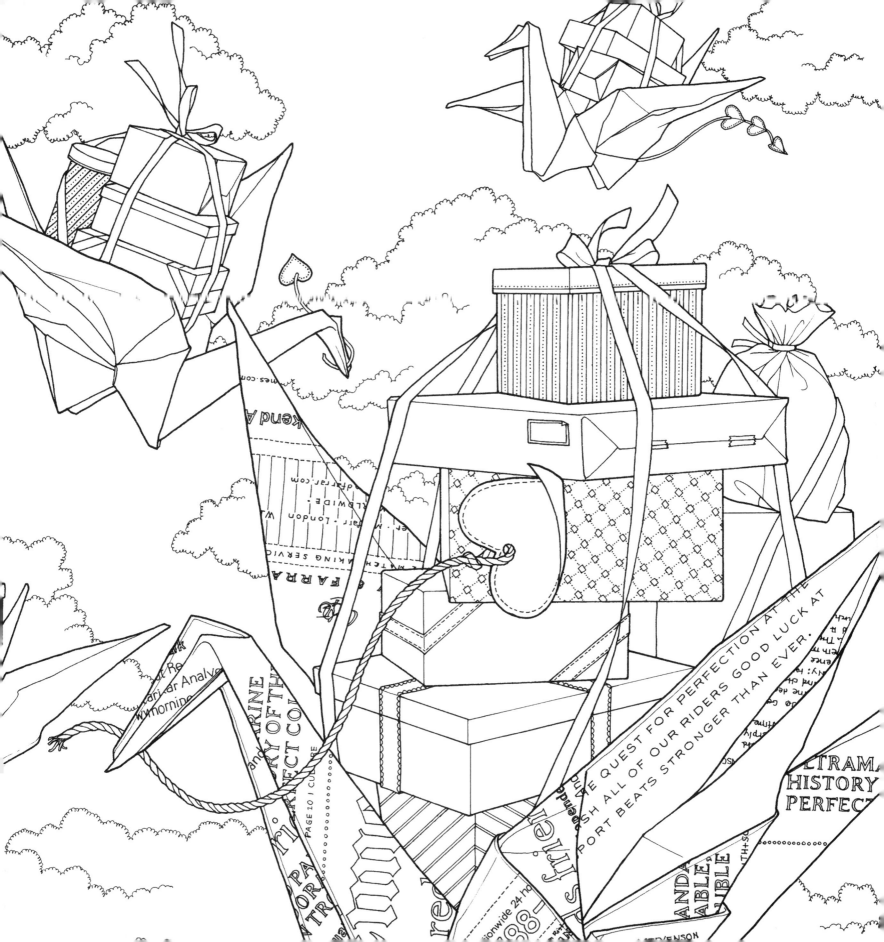

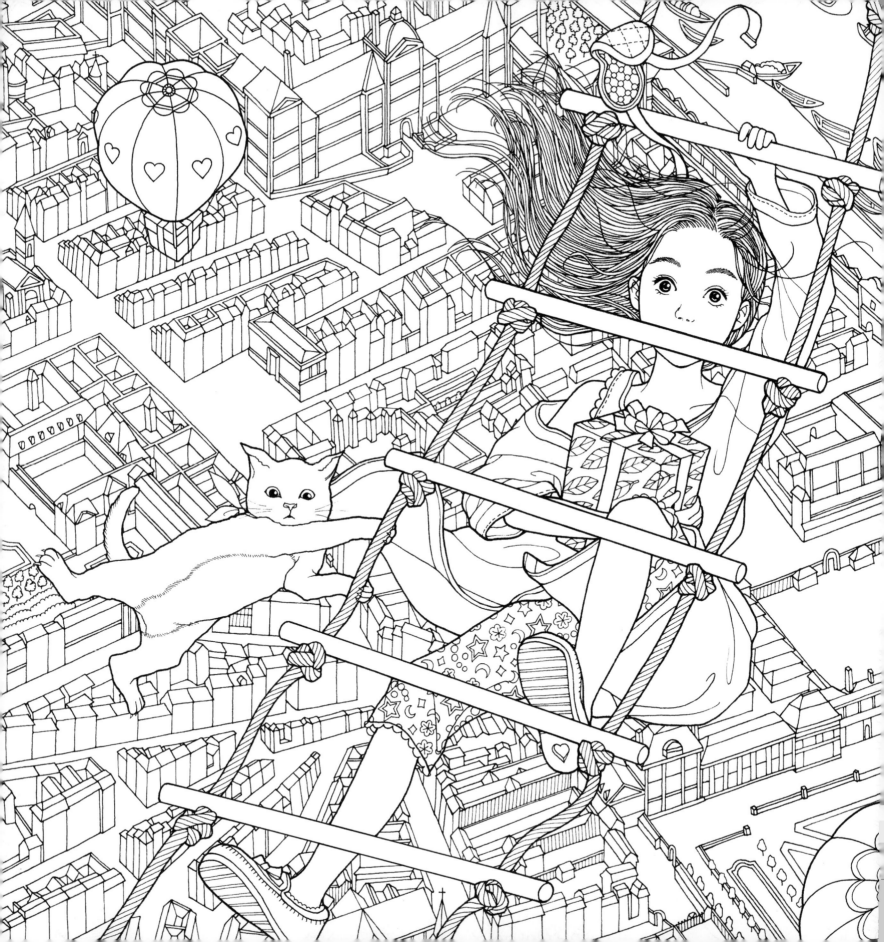

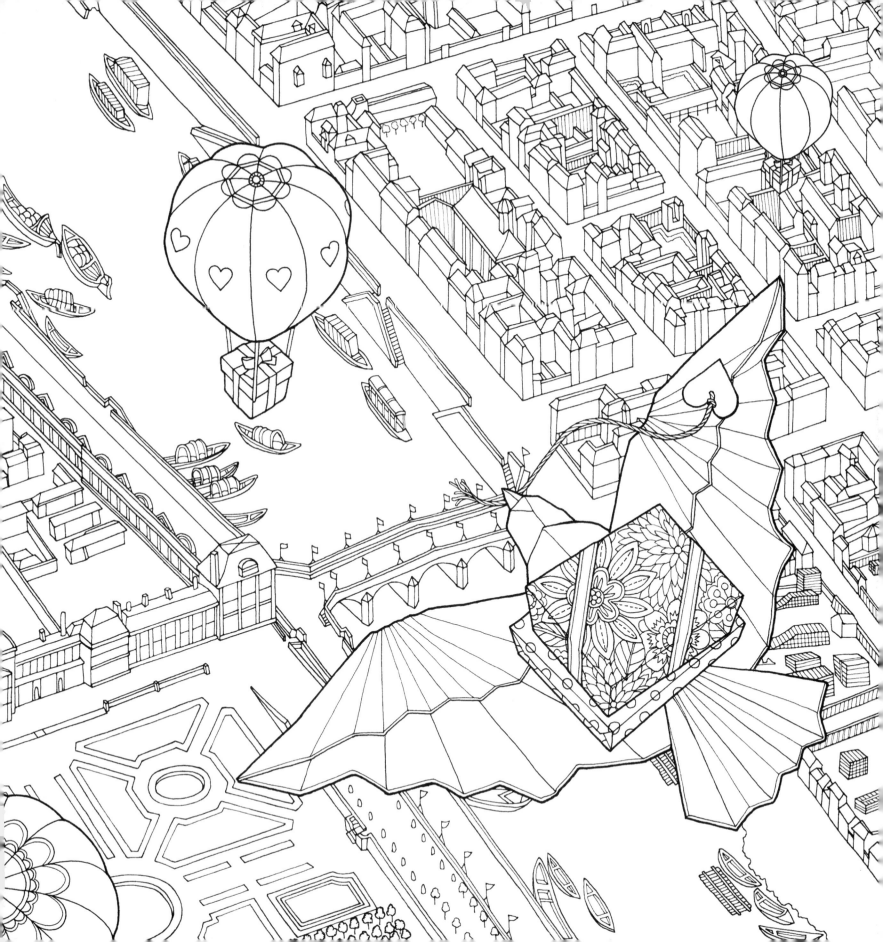

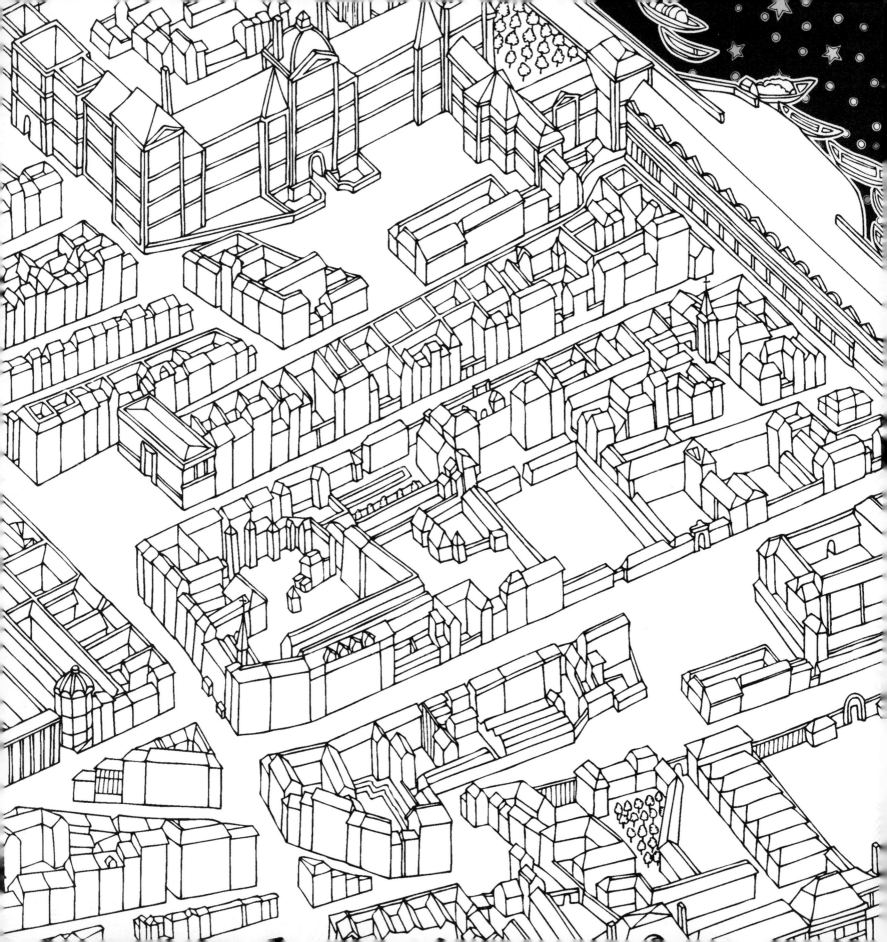

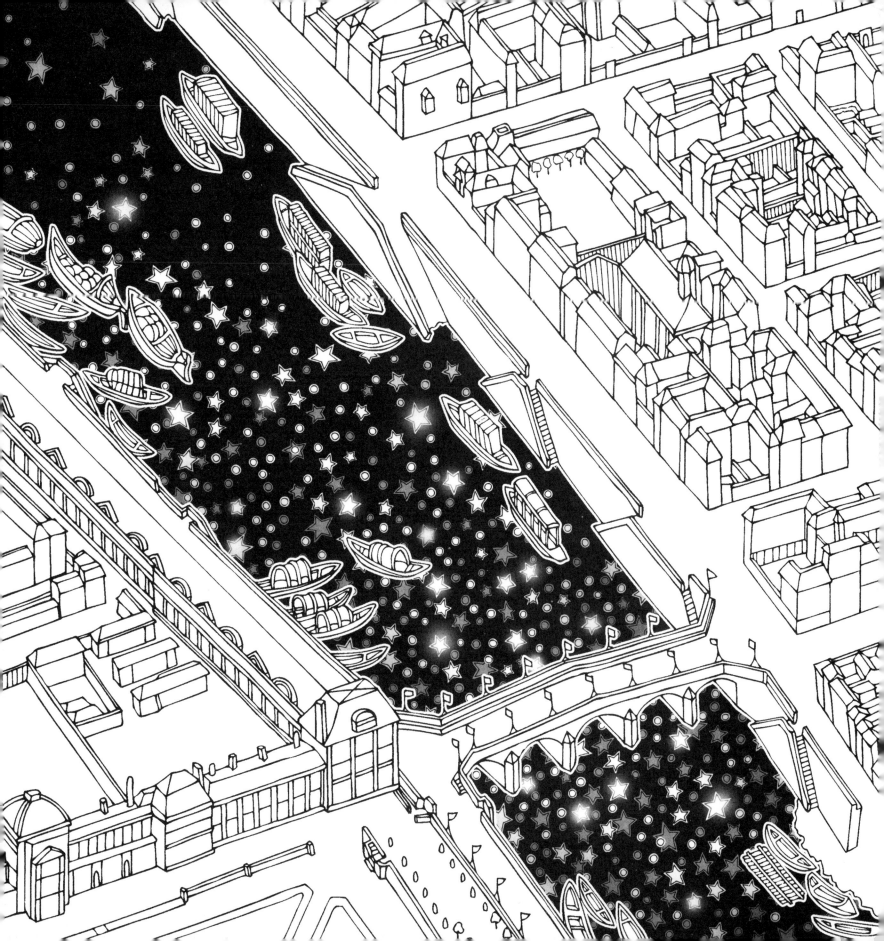

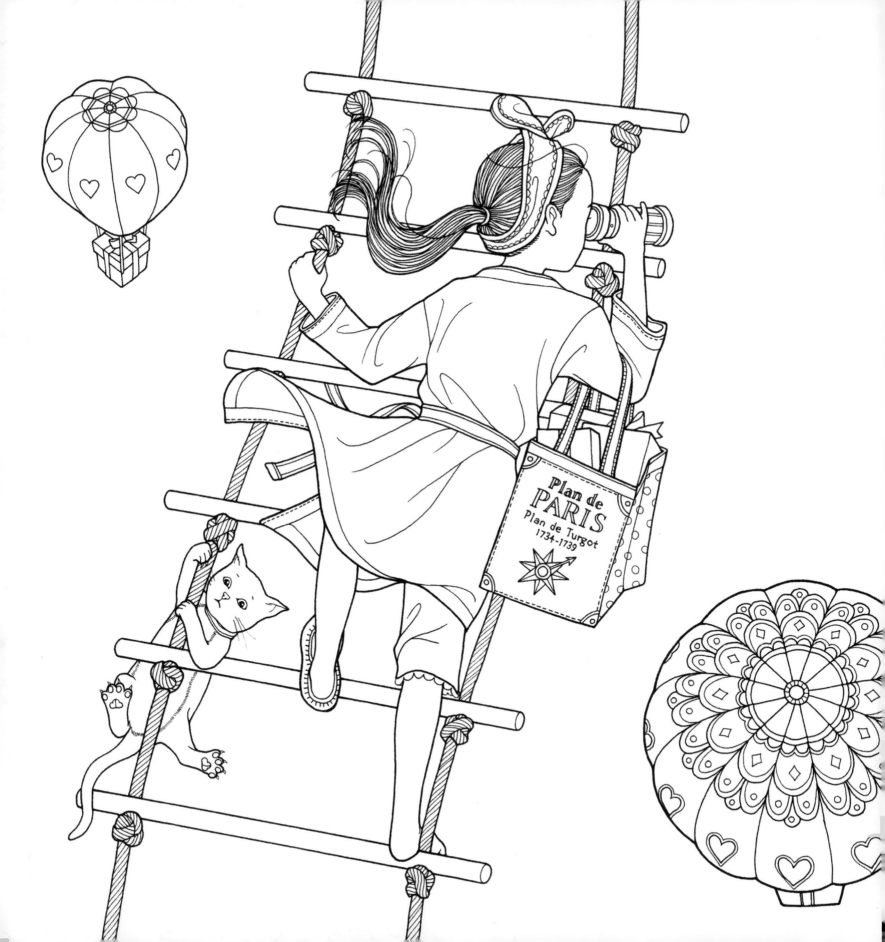

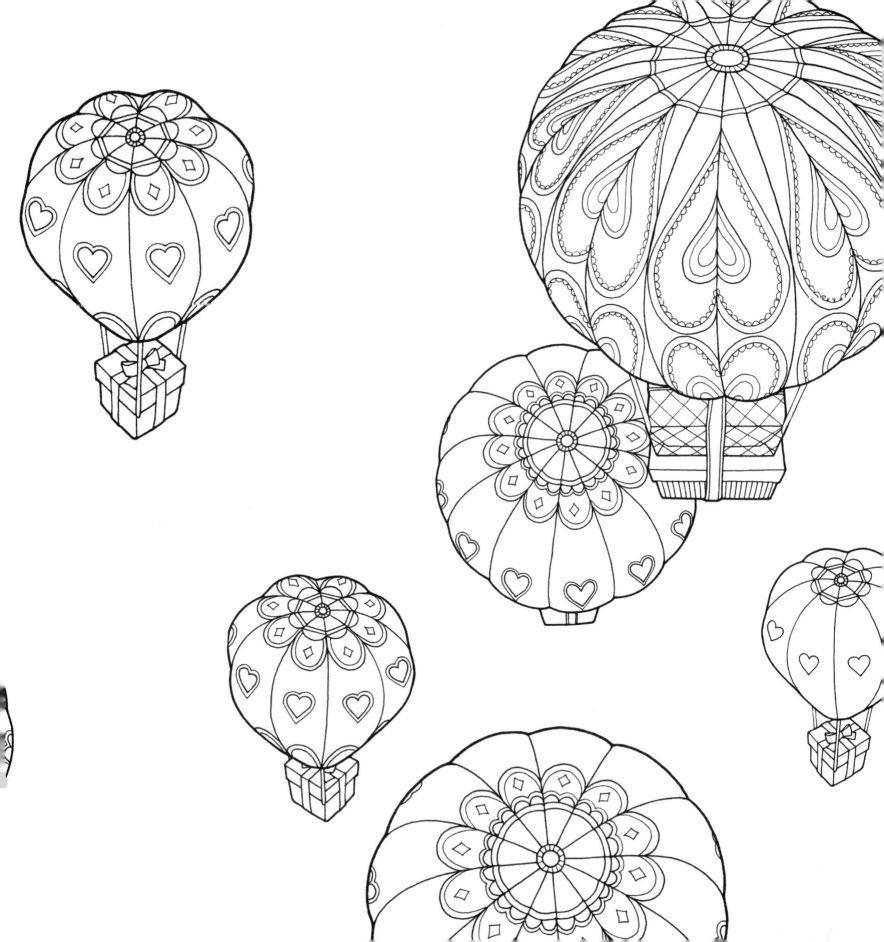

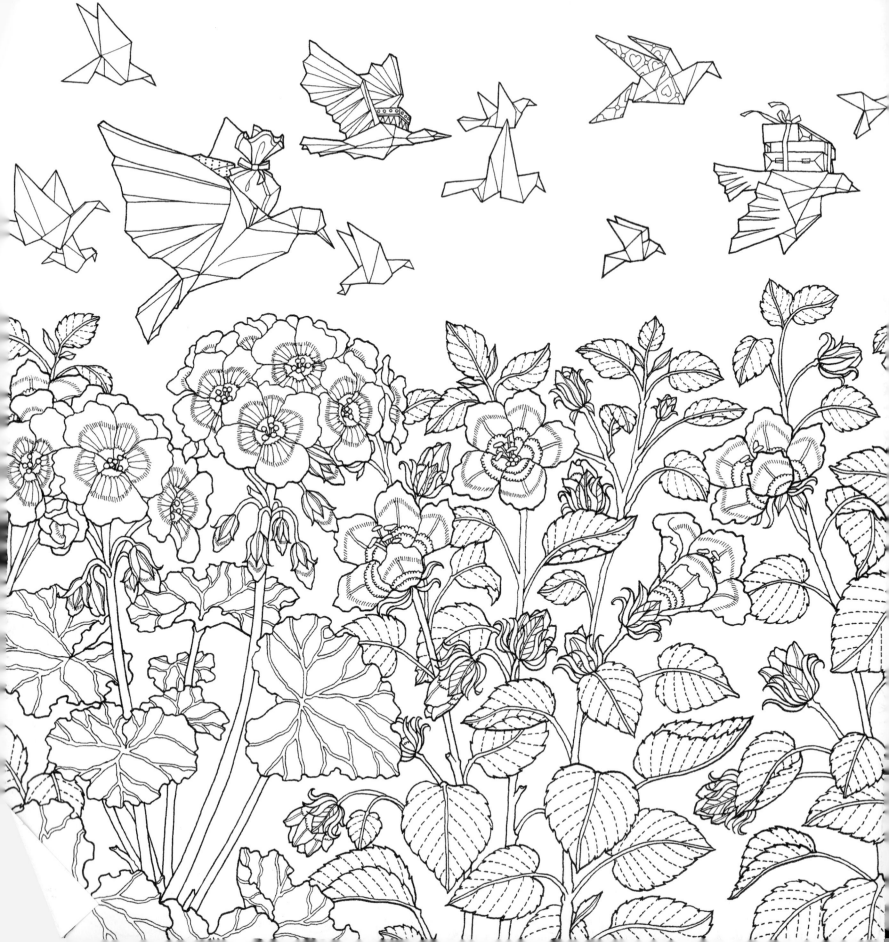

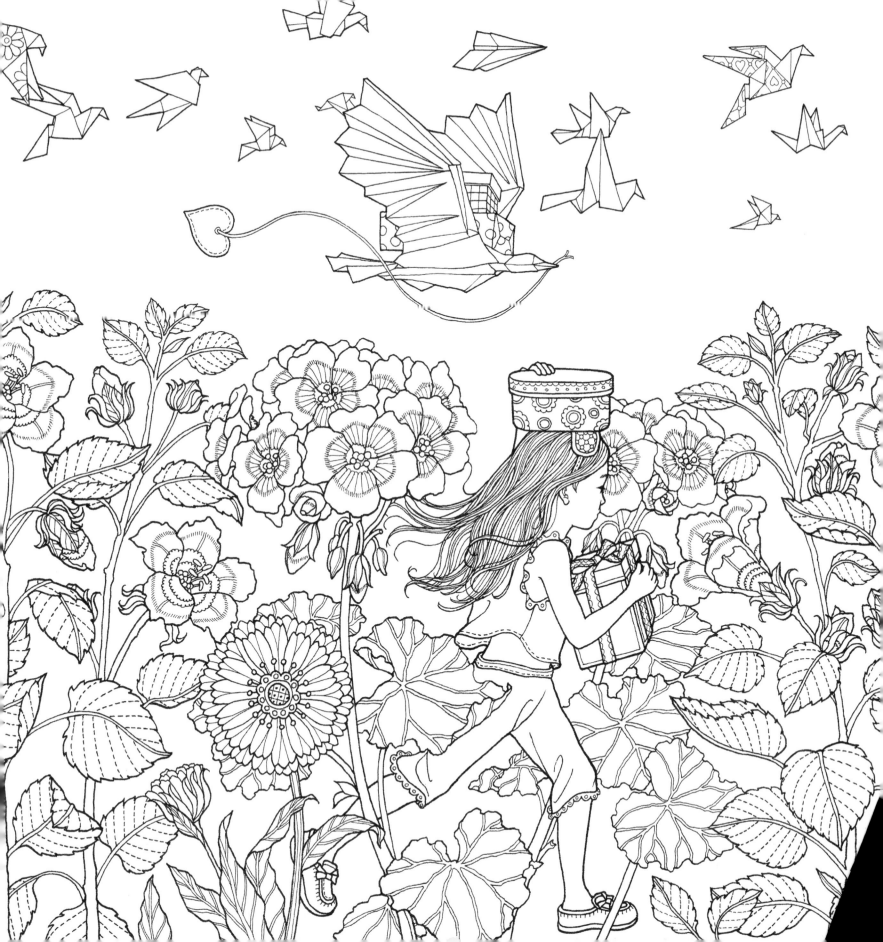

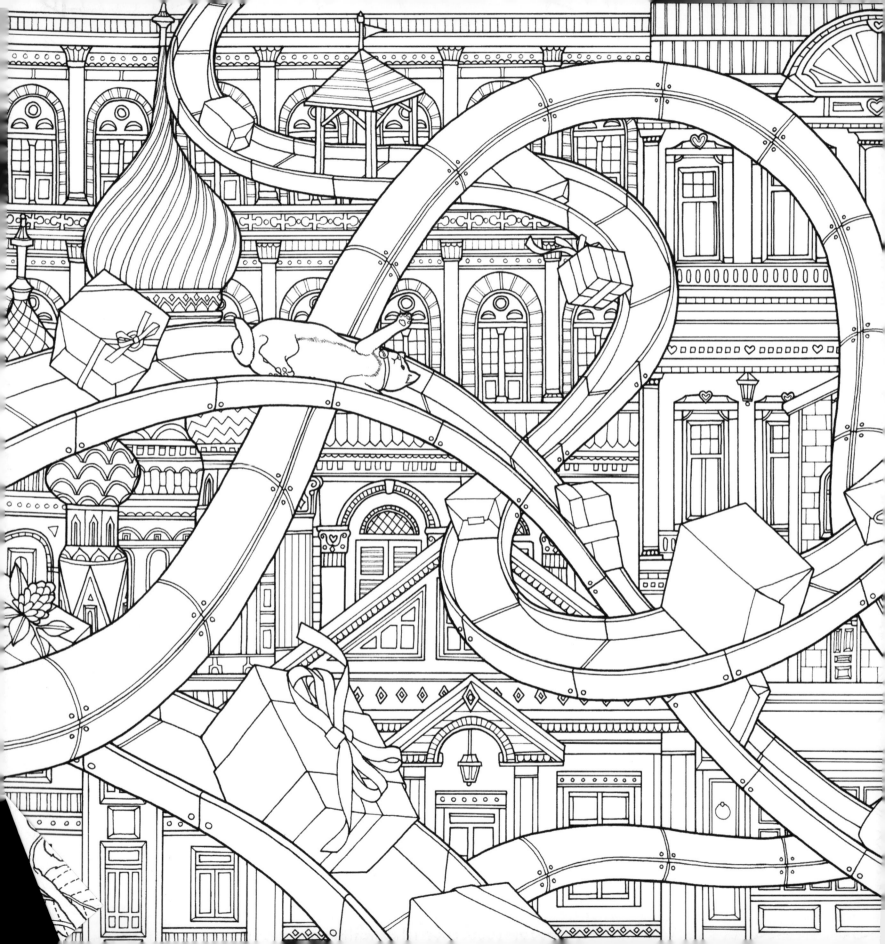

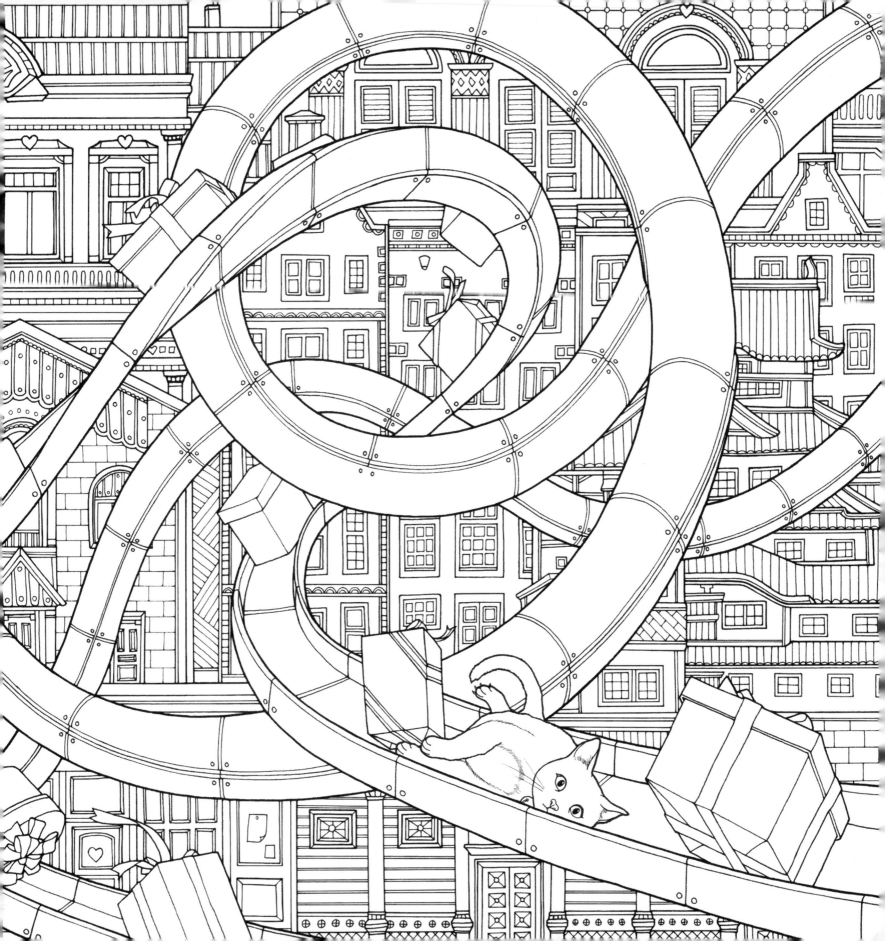

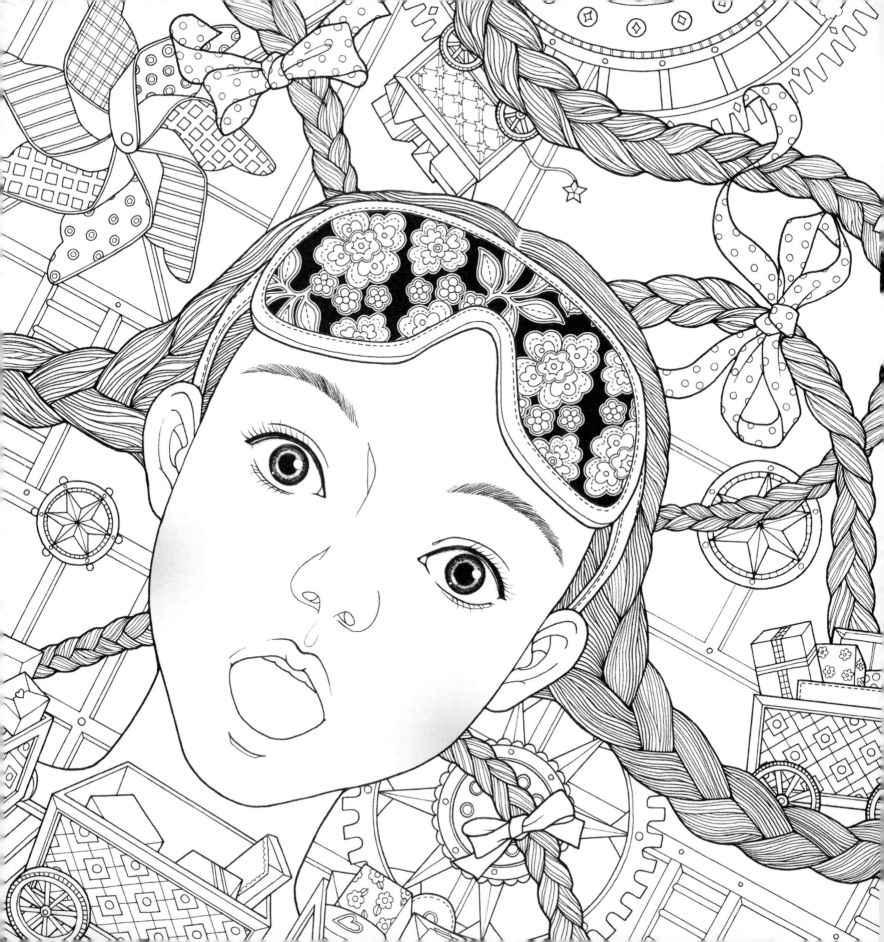

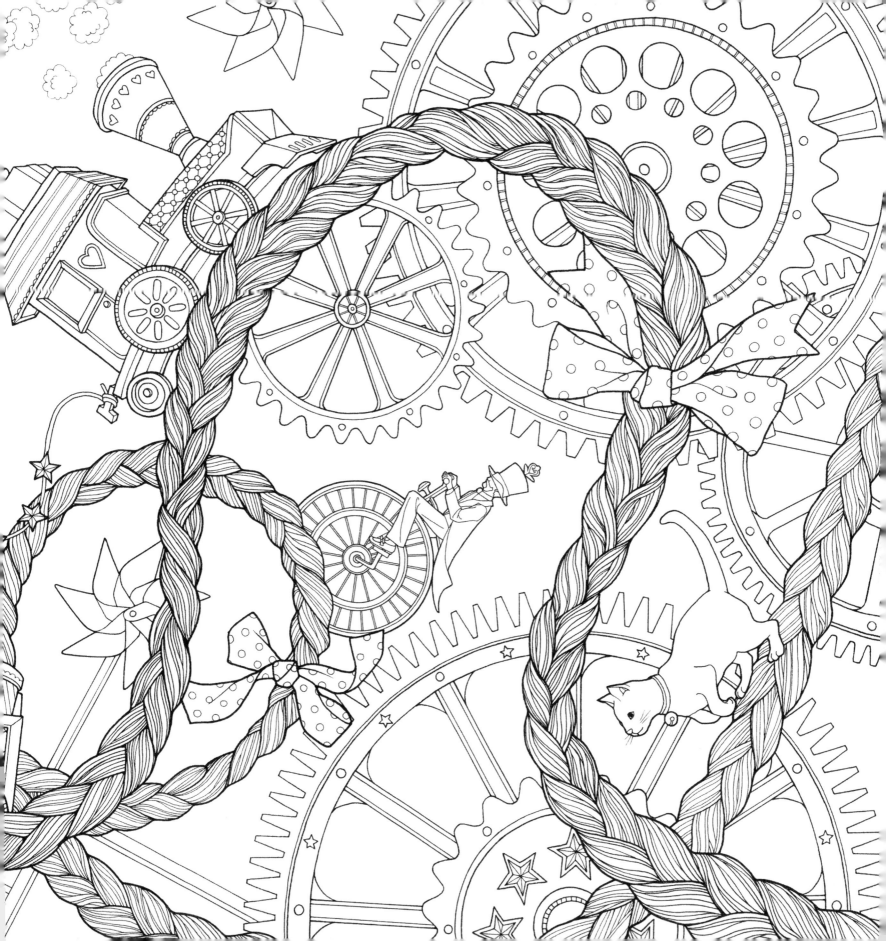

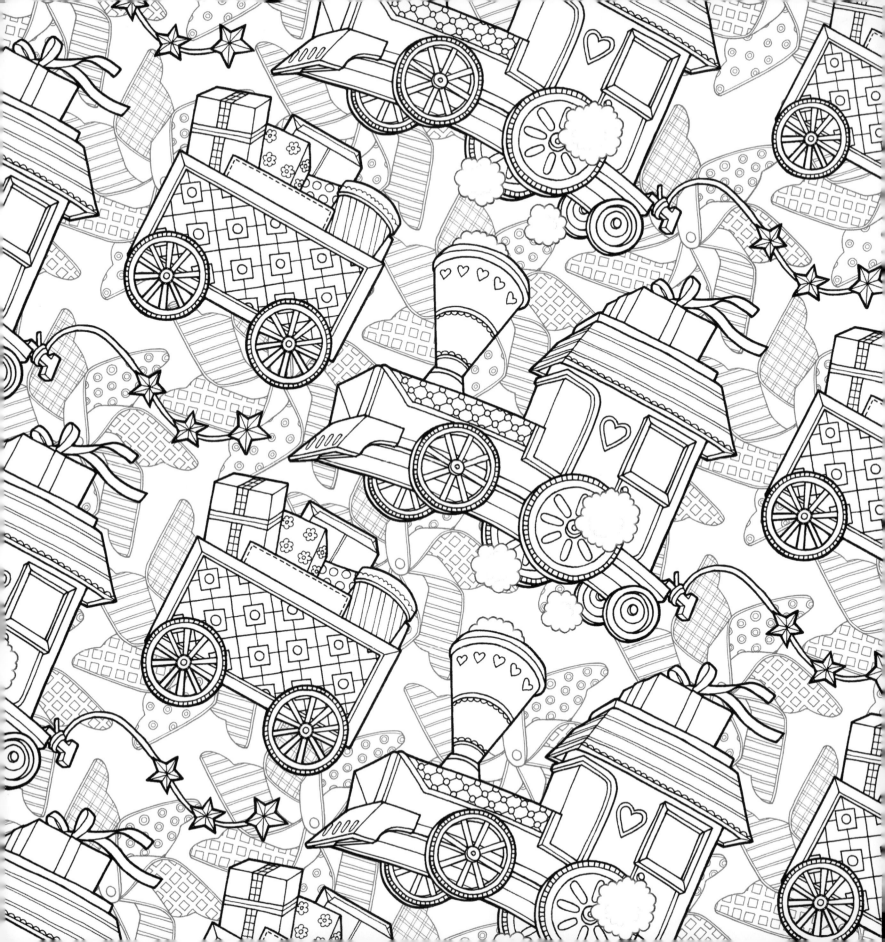

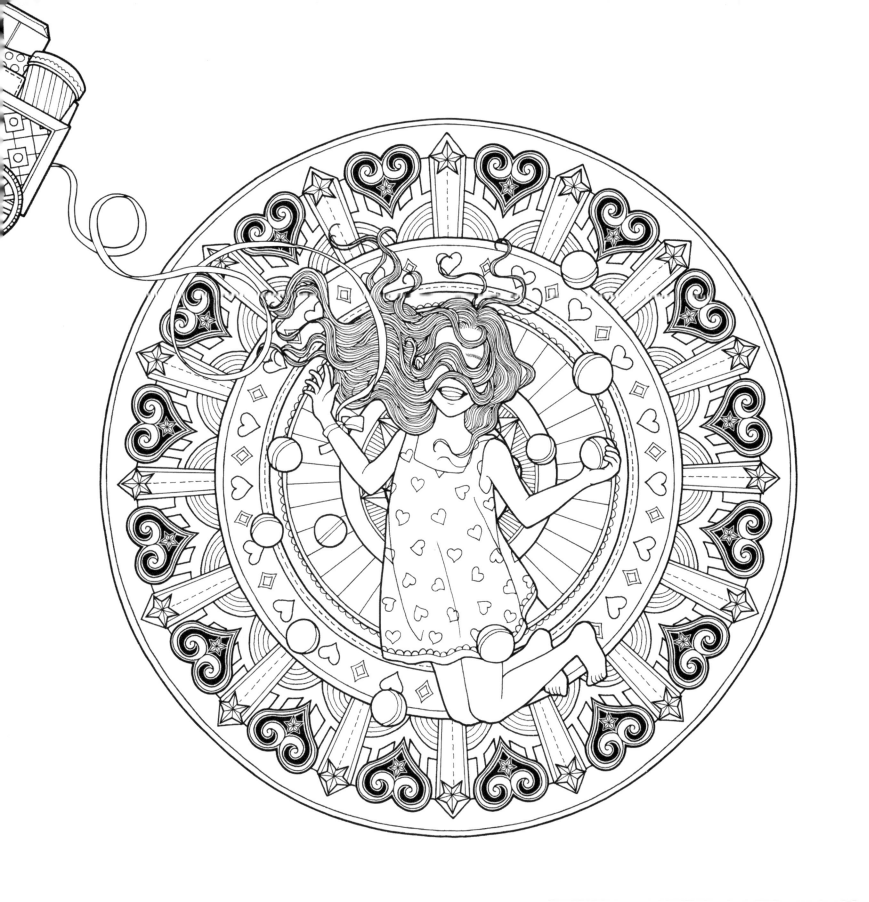

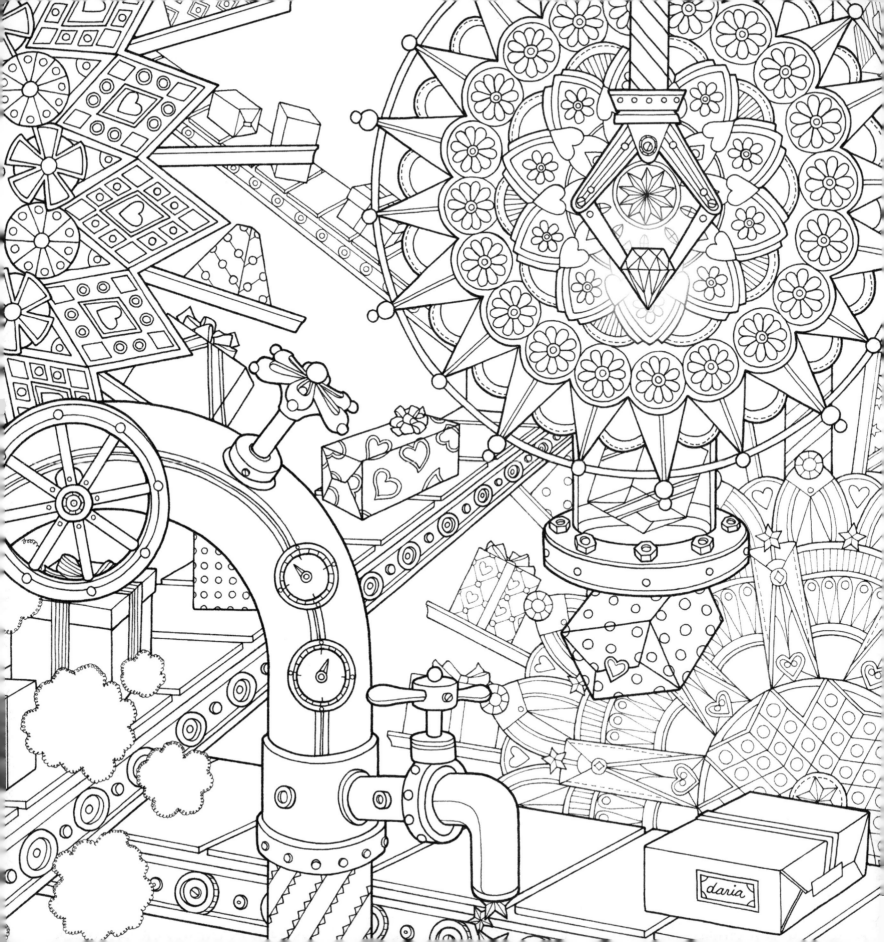

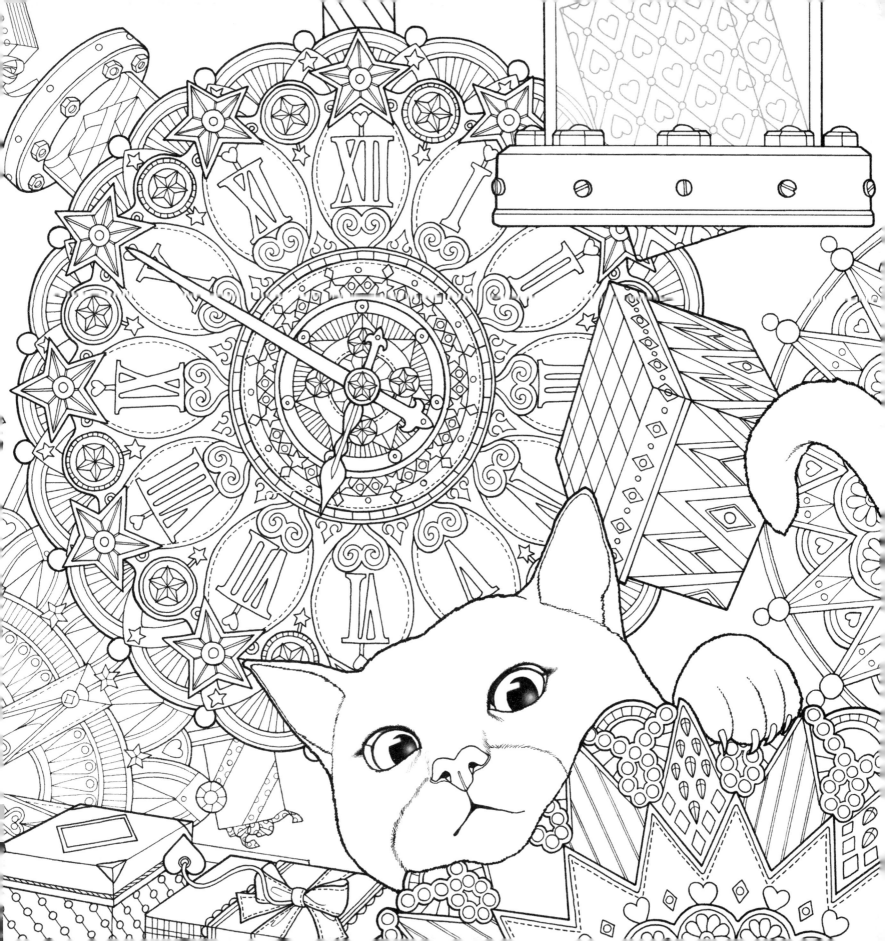

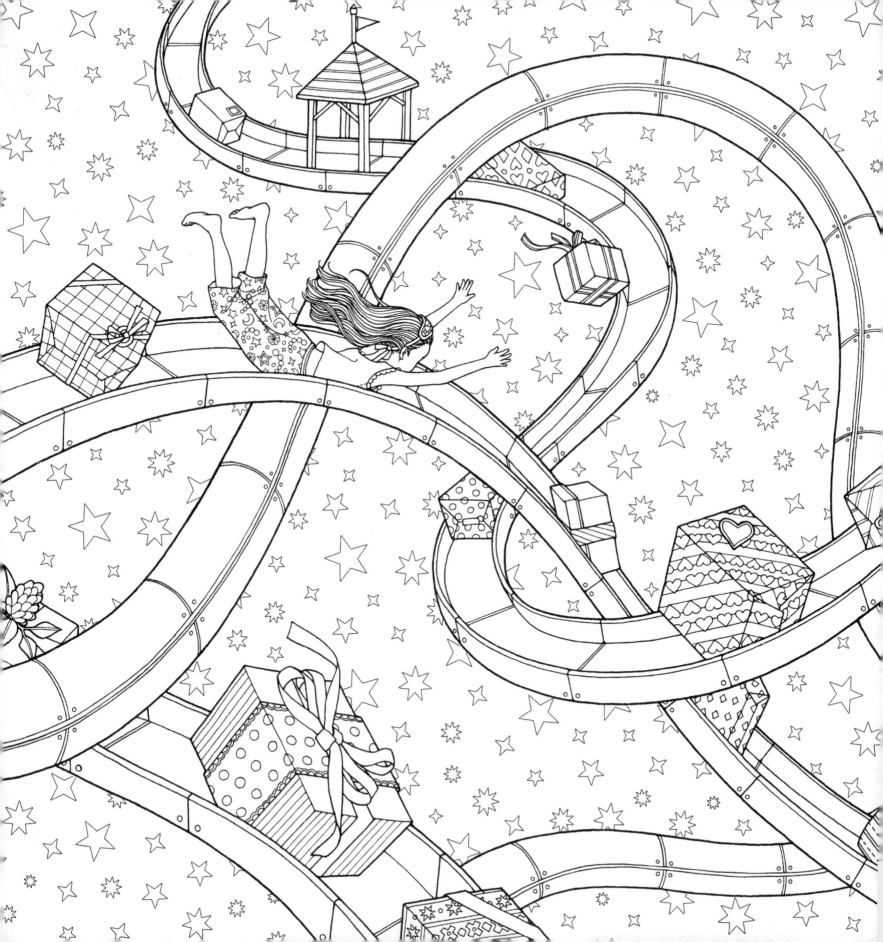

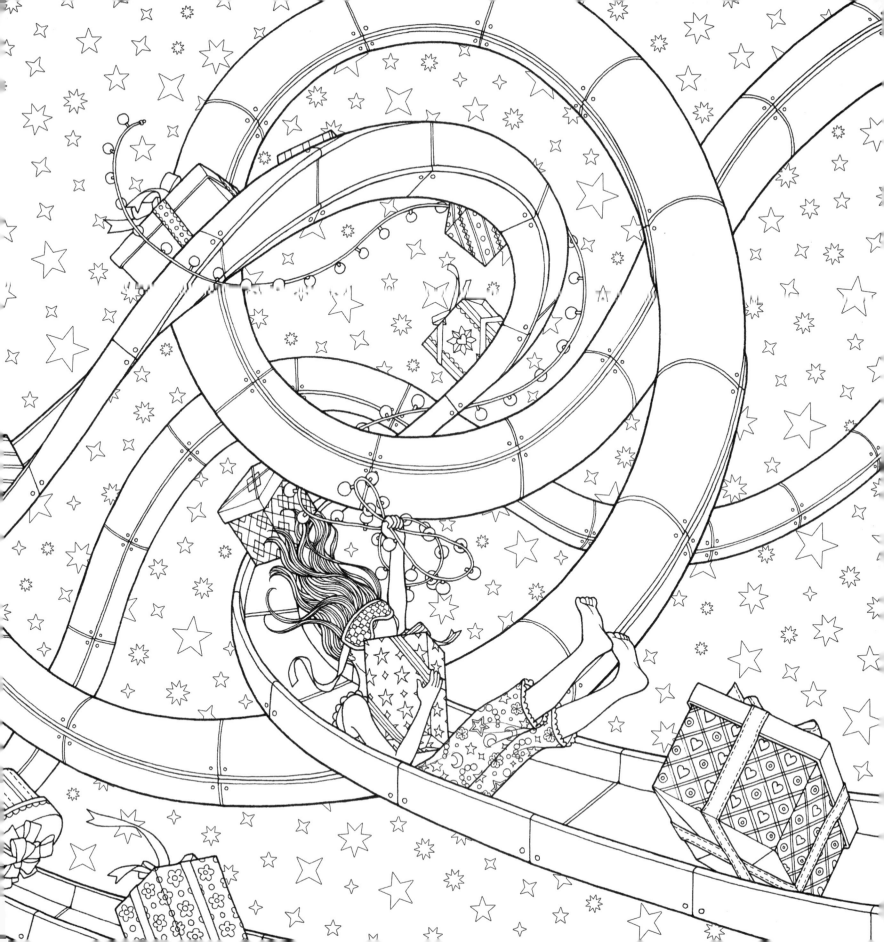

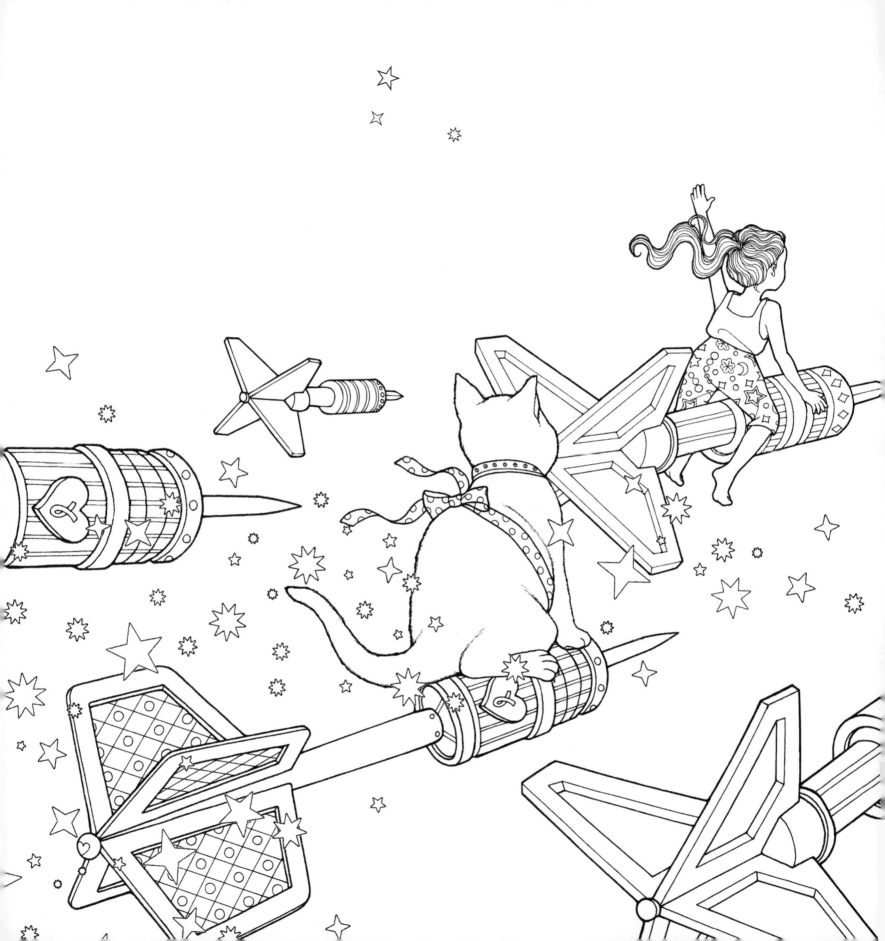

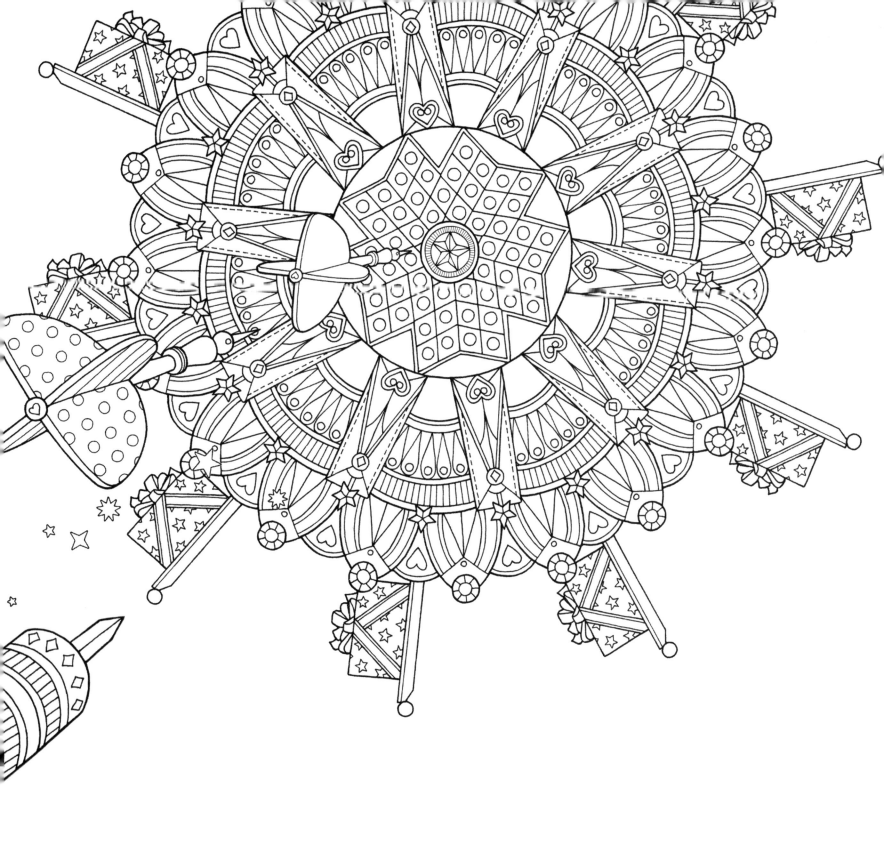

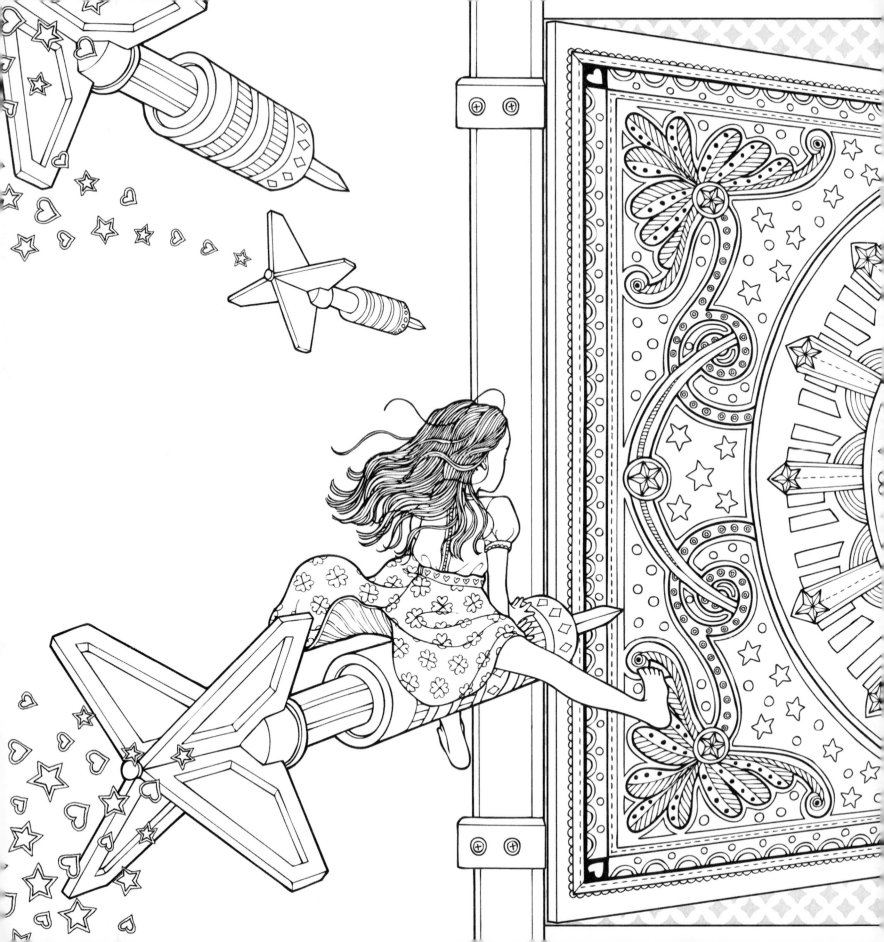

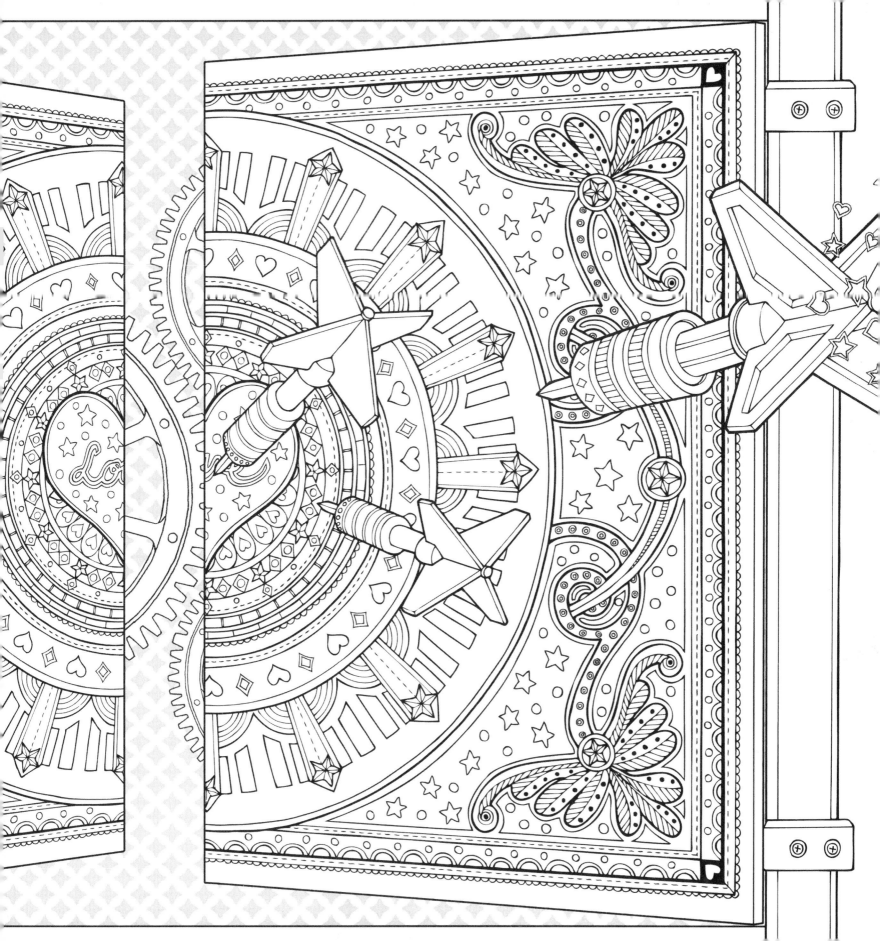

she...
breath...
came a...
she stepp...

not stay un...
At last she overtook Frederick, who desired her...
and gave him plenty to eat and drink, for he was very...

Then they hugged and...
he had had...
eaten so much that...
way he came in. This was just...
upon; and now he began to set up a gr...
making all the noise he could.

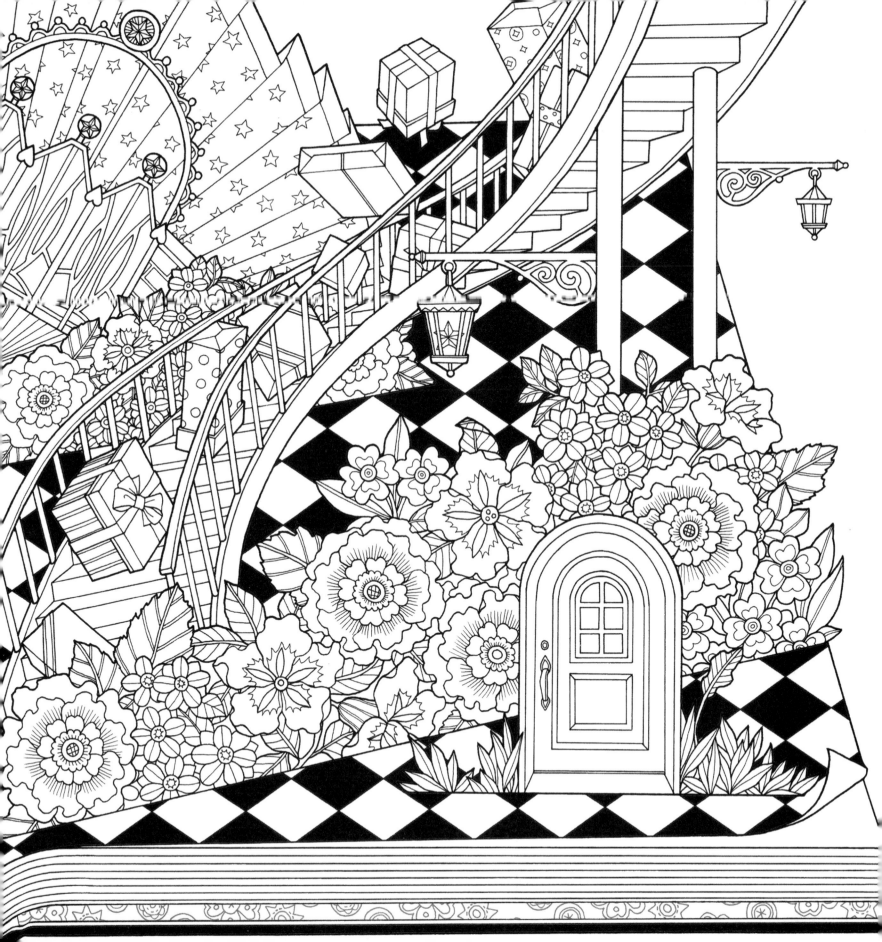

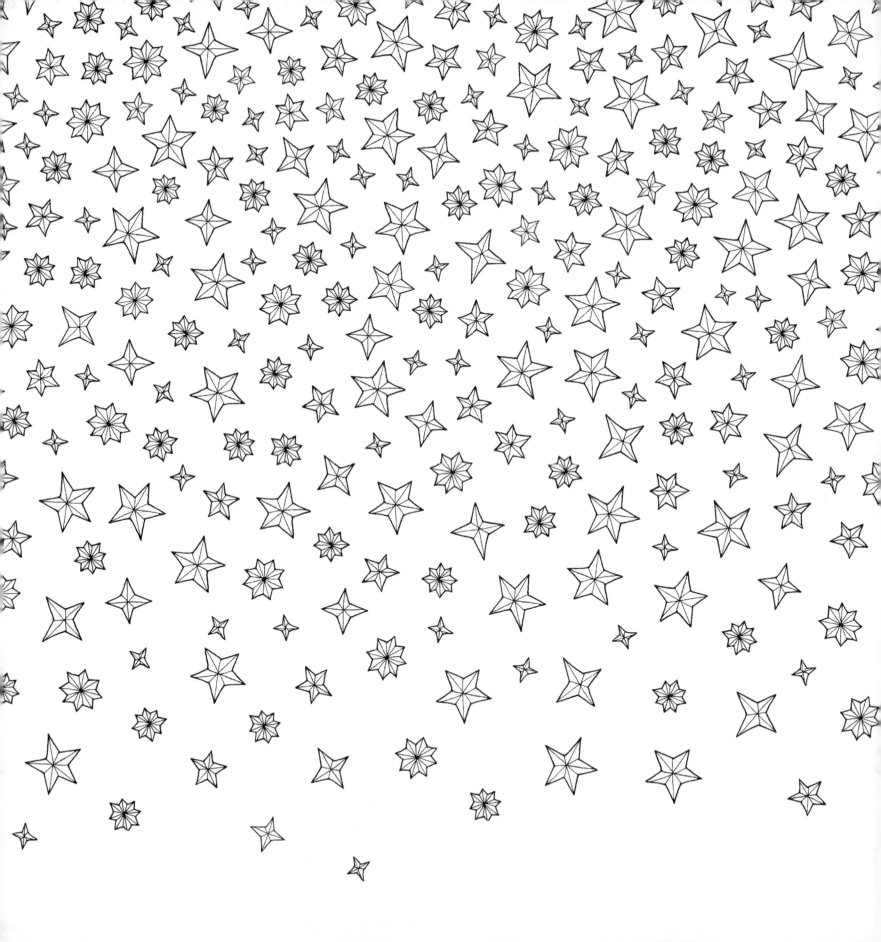

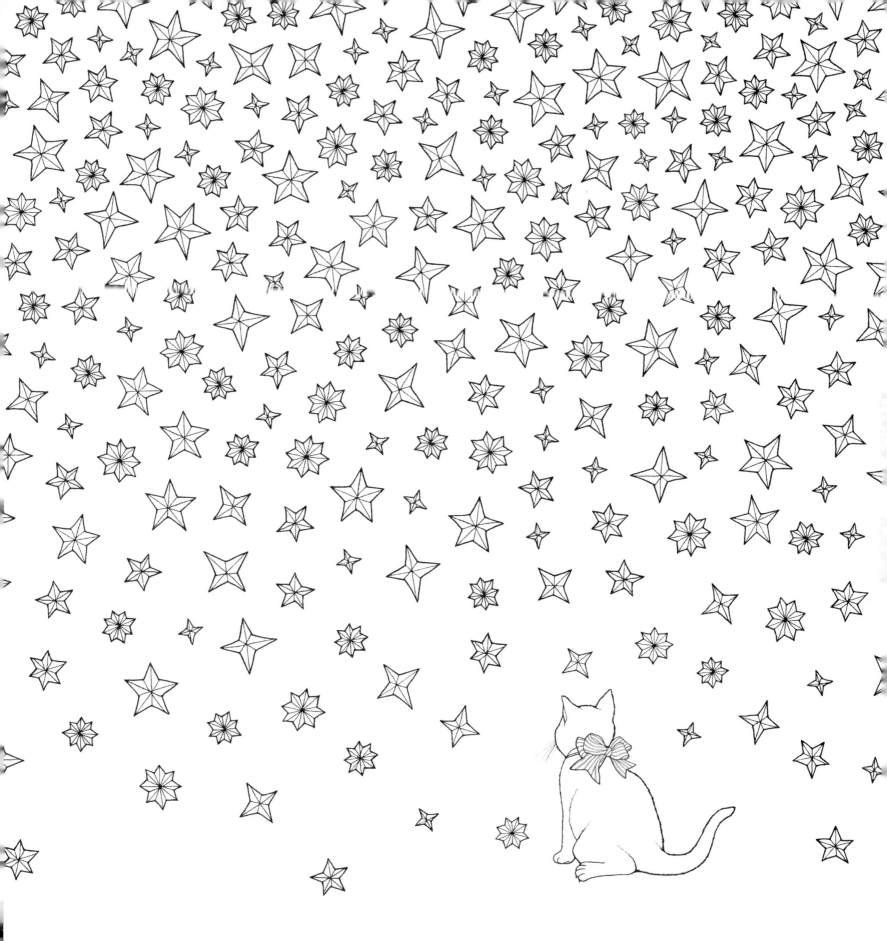

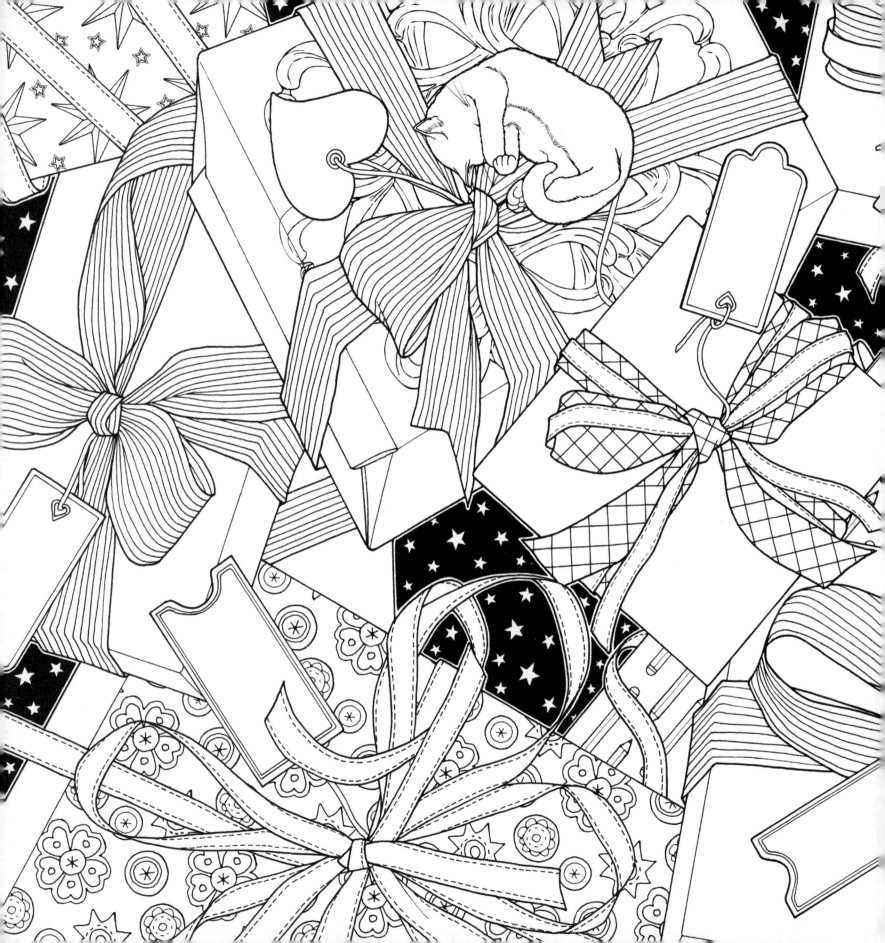

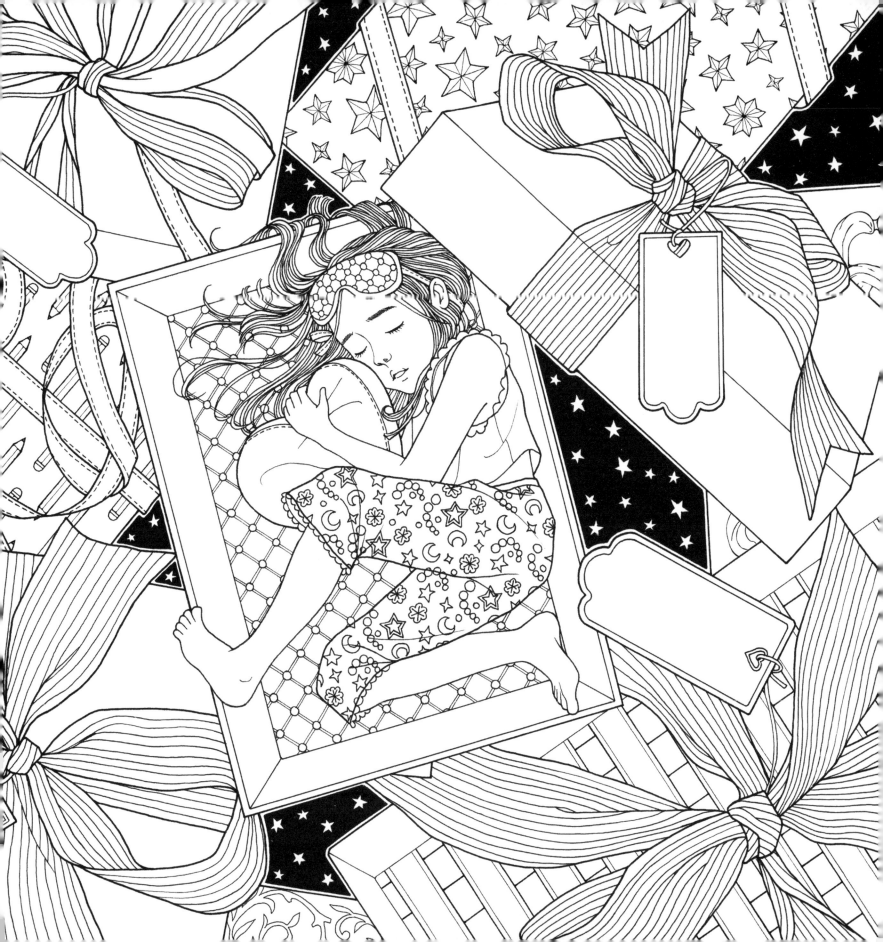

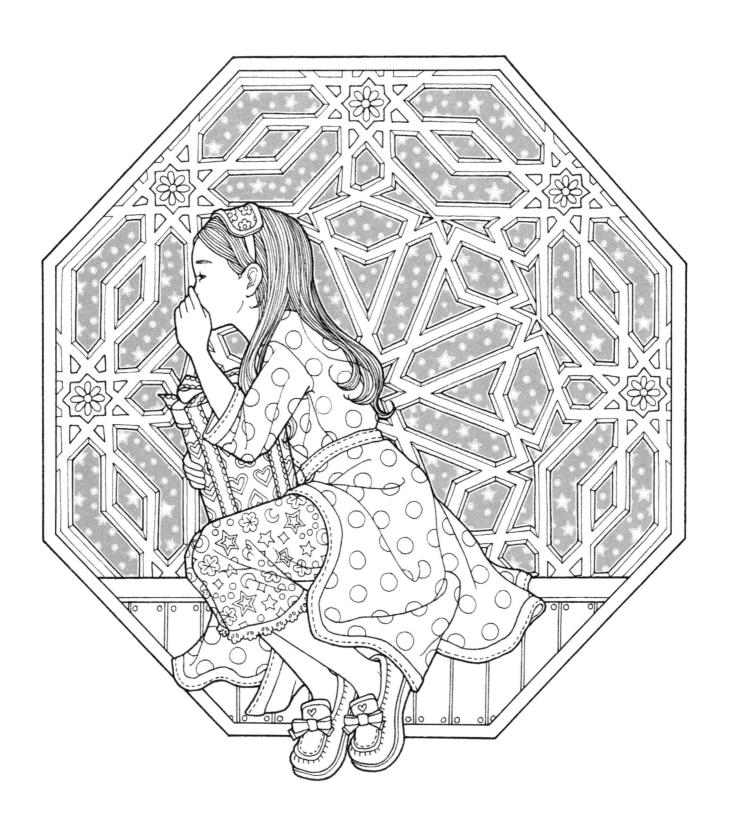

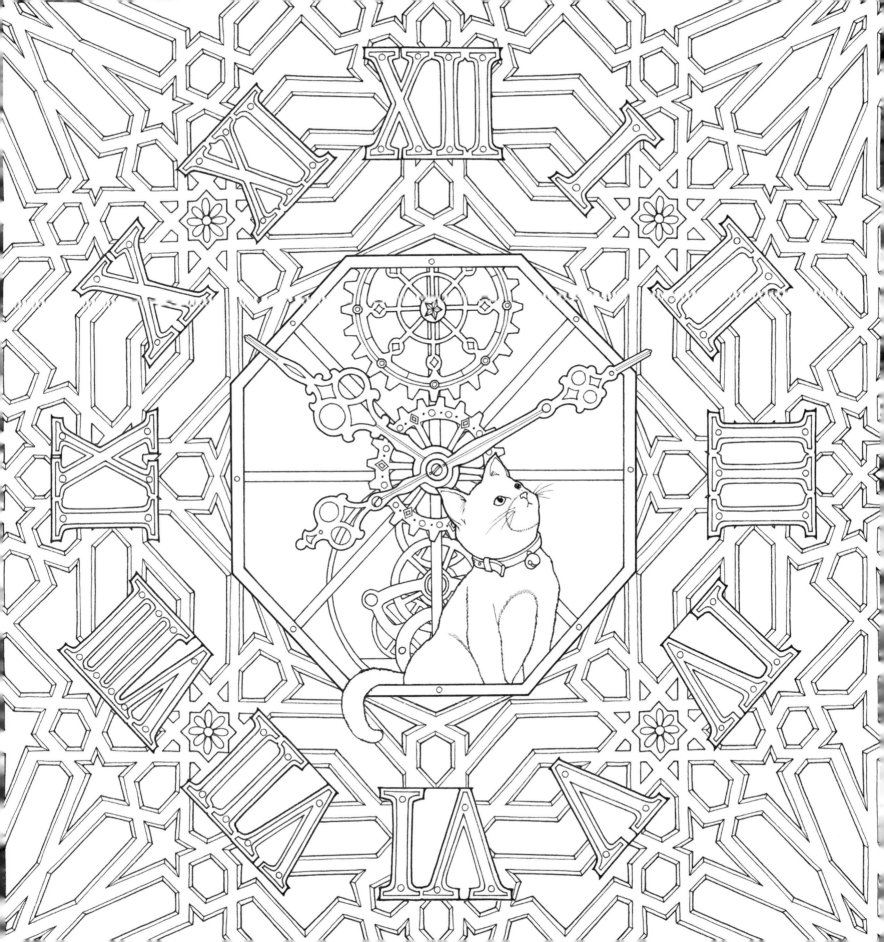

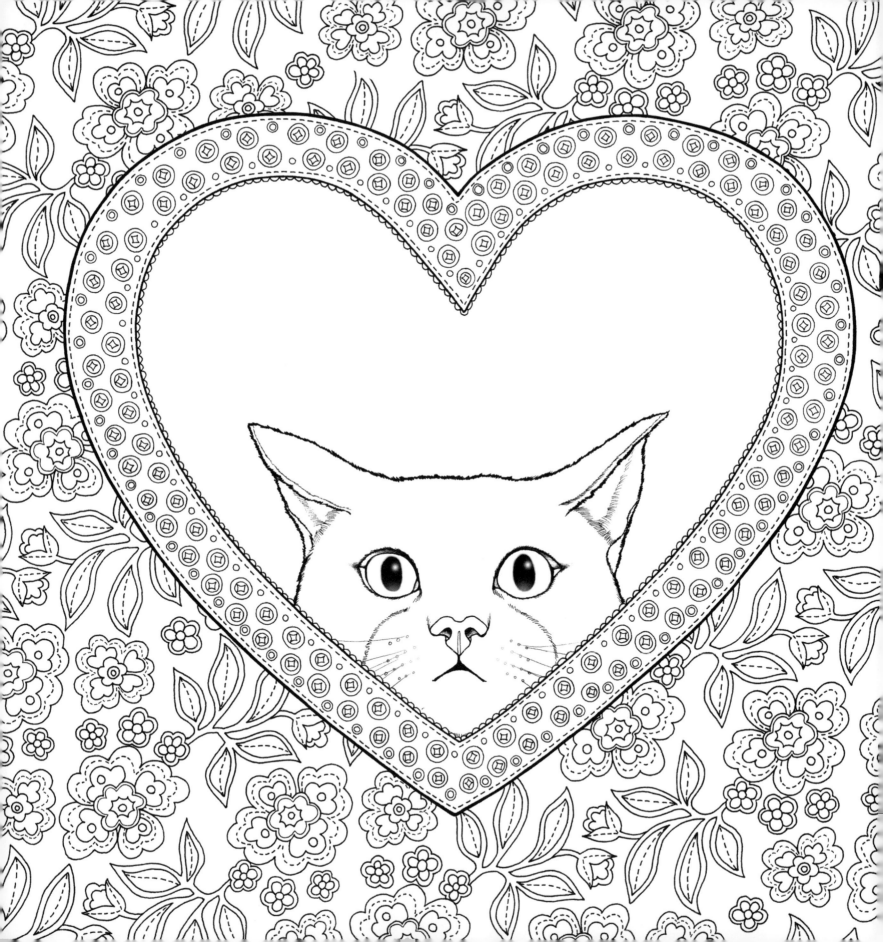

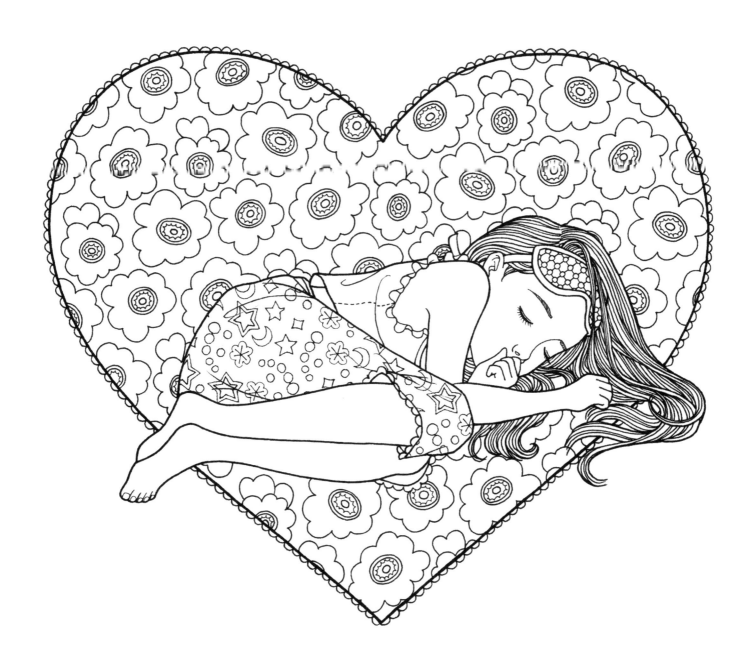

"Jingle, jingle, jingle." The little girl awoke the next morning to the sound of Phoebe's bell. Looking around, she quickly realized she was back in her bedroom. "Phoebe, was it all a dream?"

All of a sudden, she heard the clatter of silverware in the kitchen, and the scent of pancakes wafted into her room.

Her parents had come home early after all! It really was the best present in the world. And as Phoebe nonchalantly licked her paws, it almost looked like she was smiling to herself.

✧

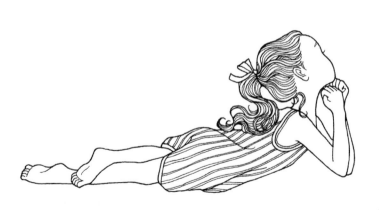

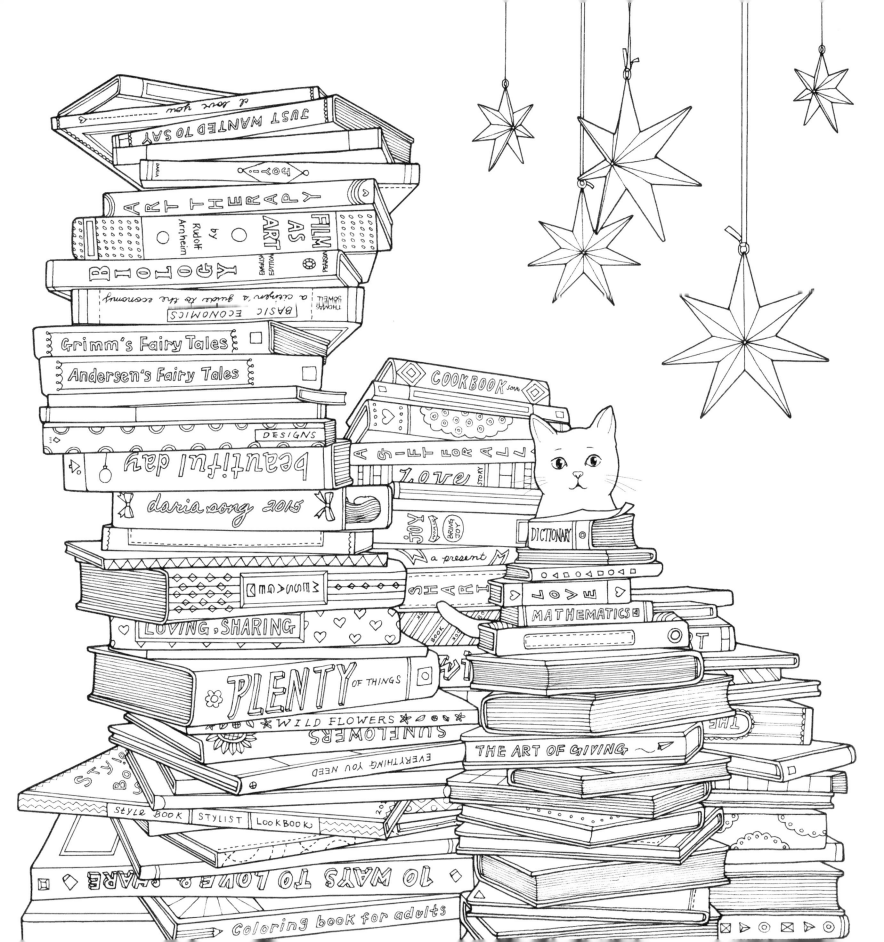

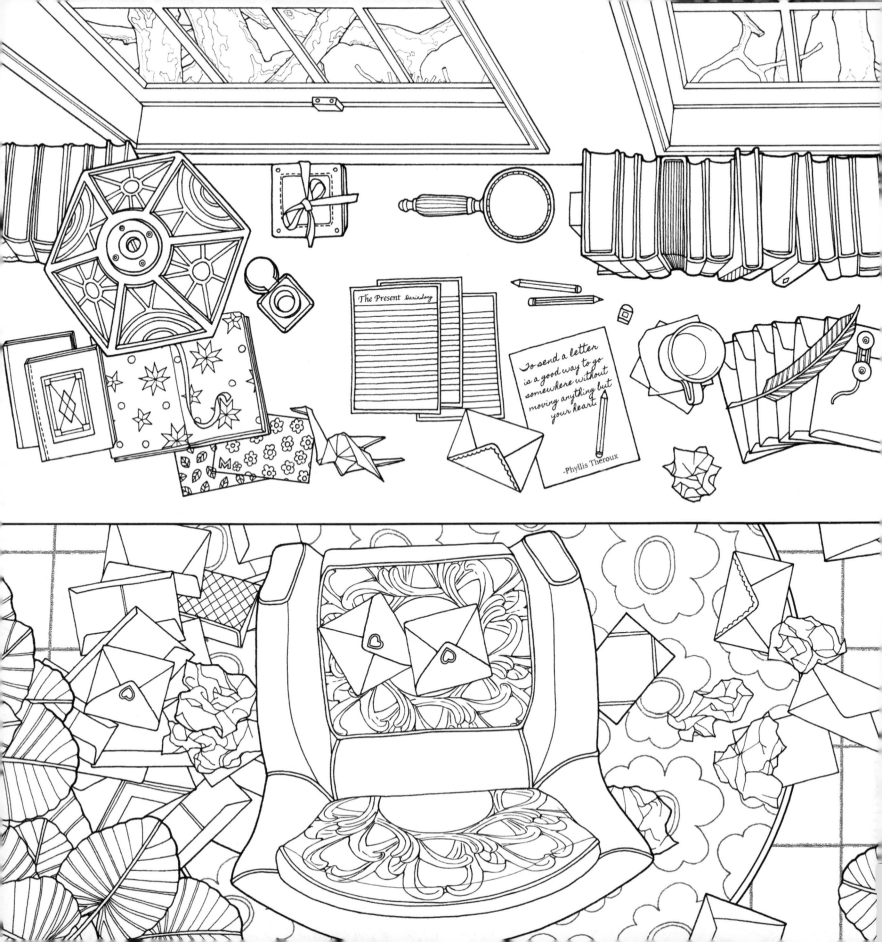

The Present Daria Long

To send a letter
is a good way to go
somewhere without
moving anything but
your heart.

-Phyllis Theroux

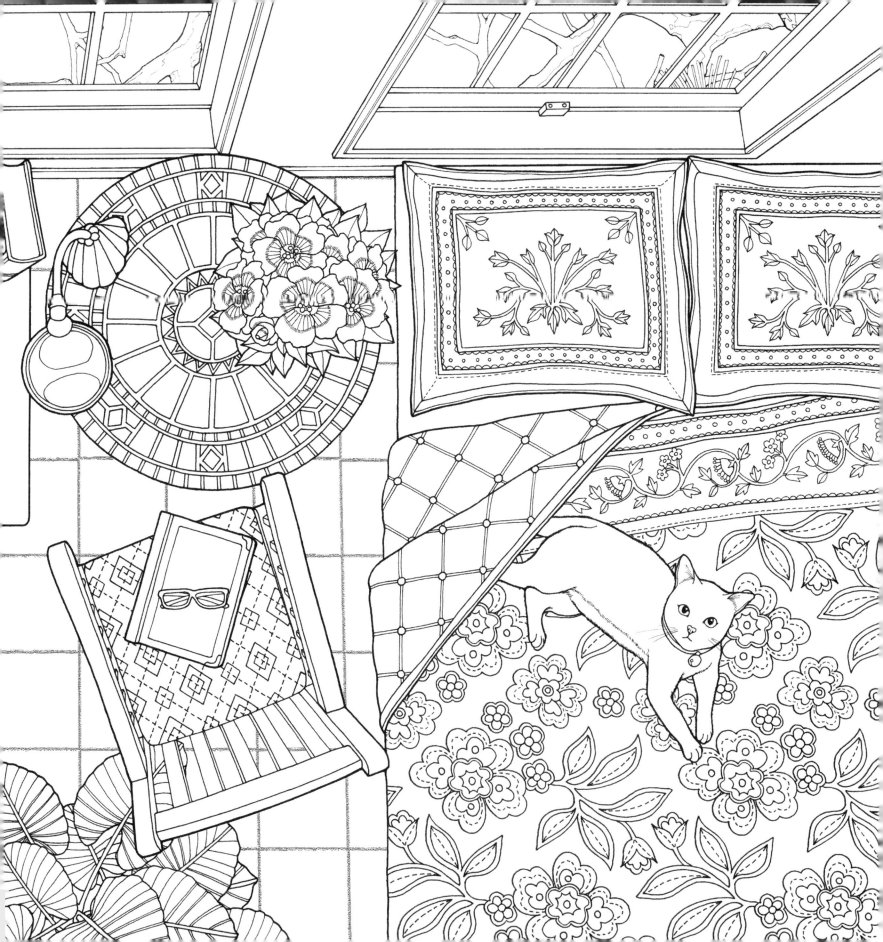

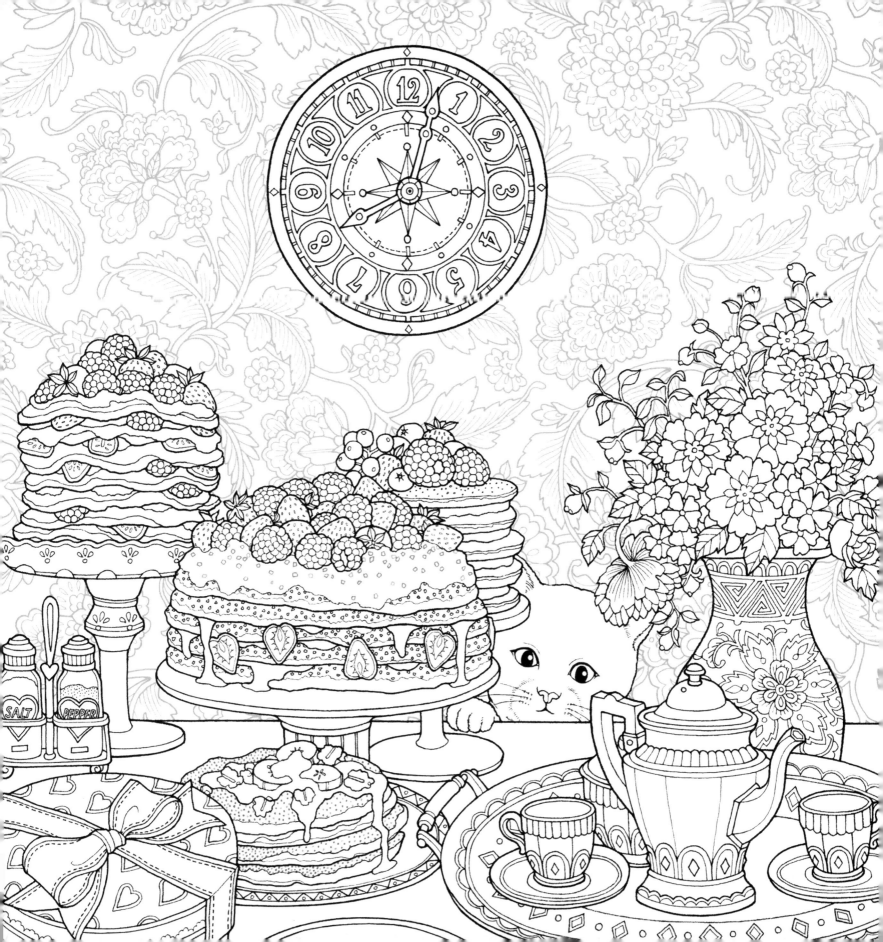

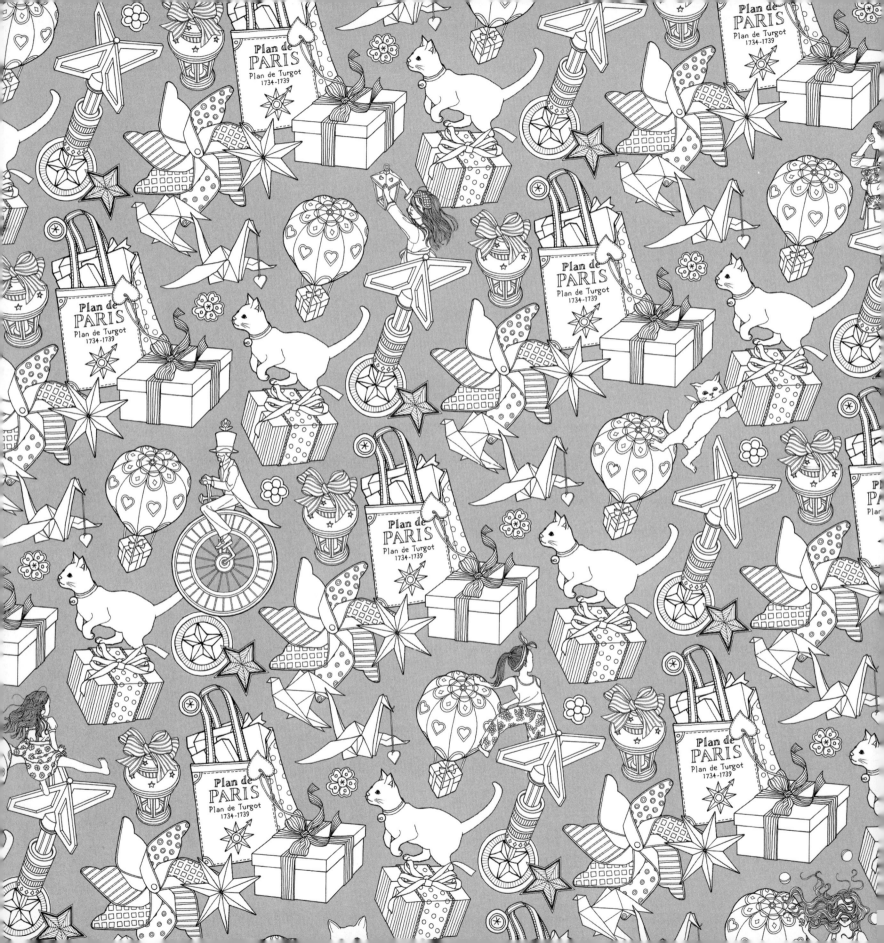

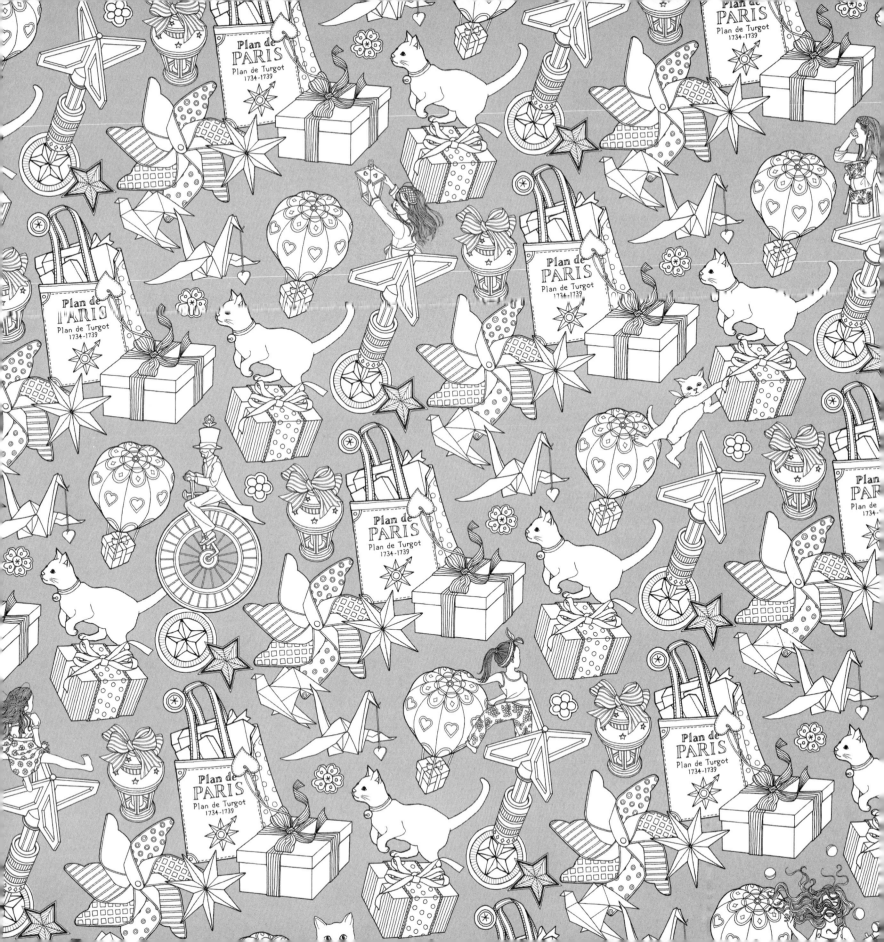

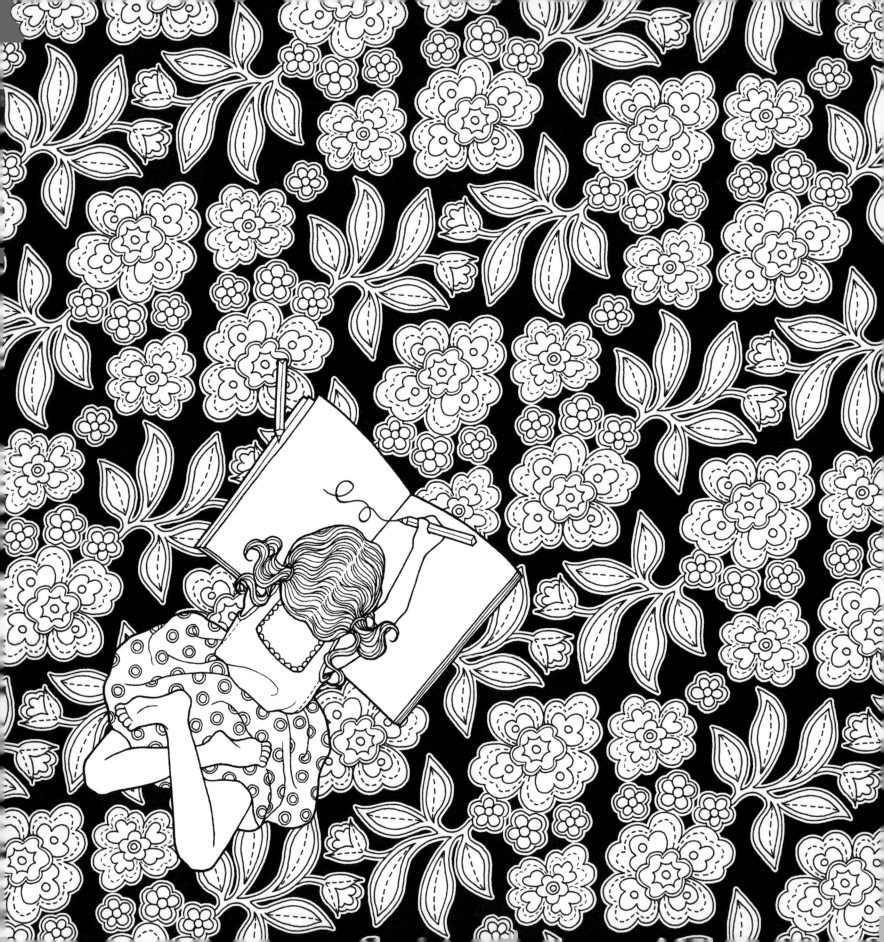

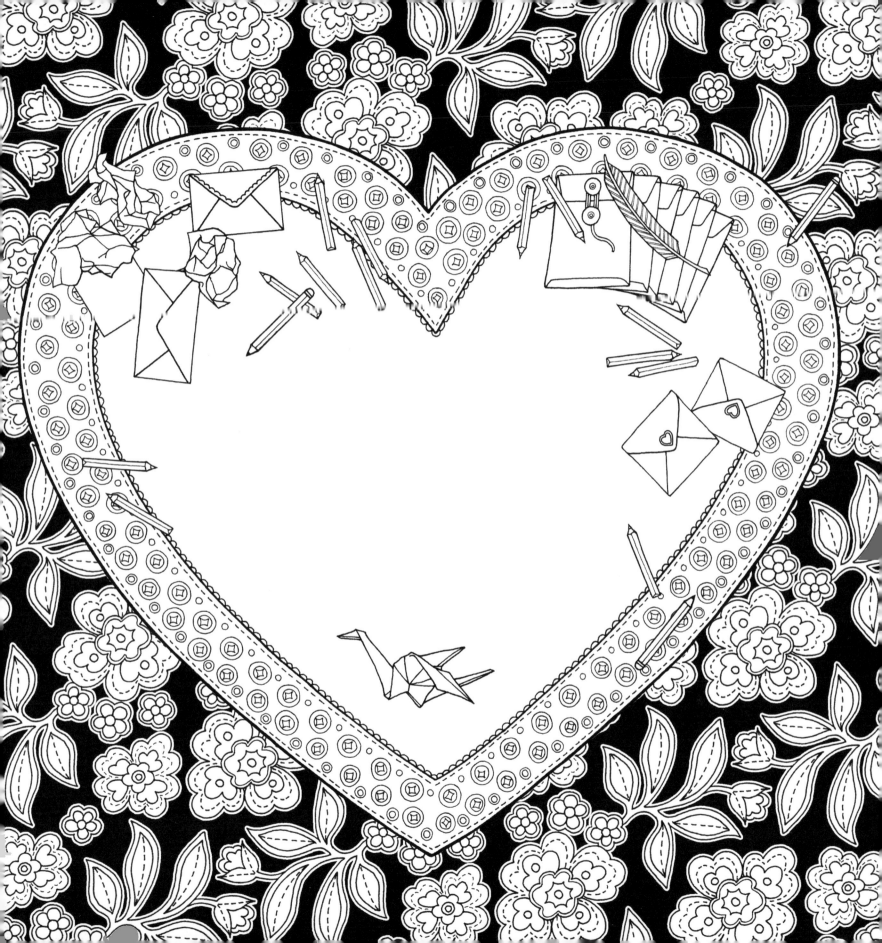

Visual Index

Grand Opening

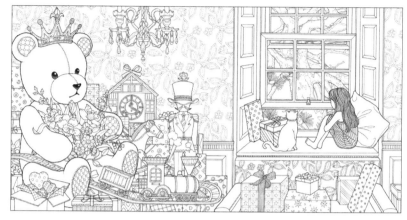

A Room Full of Presents

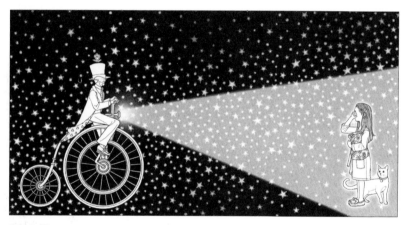

Who's There

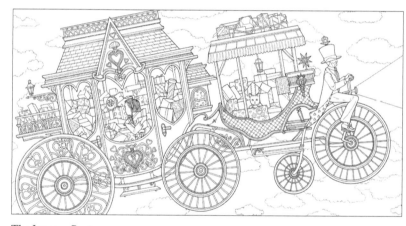

The Journey Begins

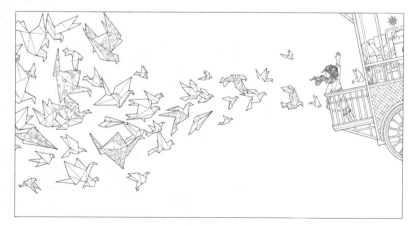

Messenger

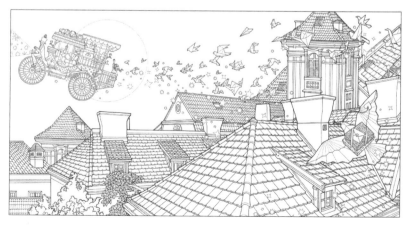

Far Far Away

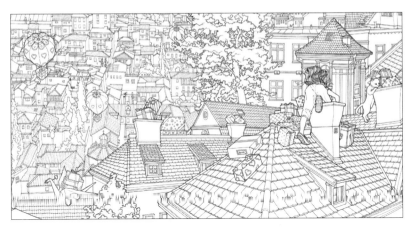

Chim Chimney

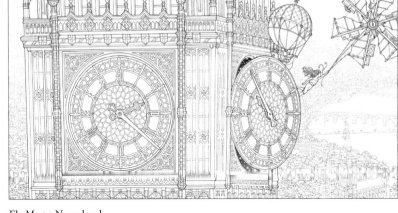

Fly Me to Neverland

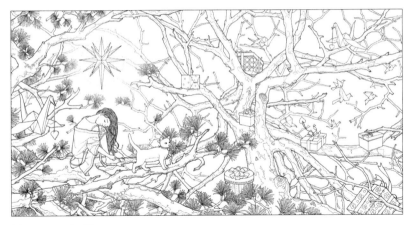

Napping in the Trees

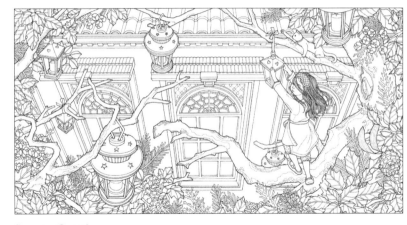

Surprise Outside

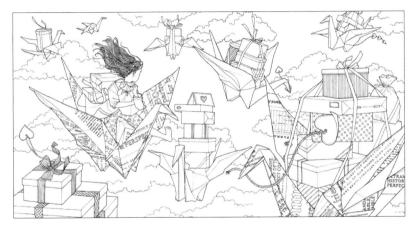

If Presents Fell from the Sky

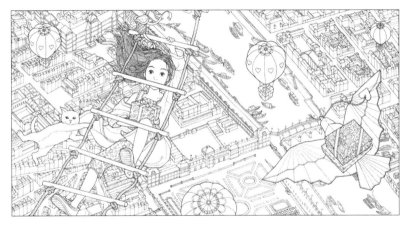

Hold on Tight

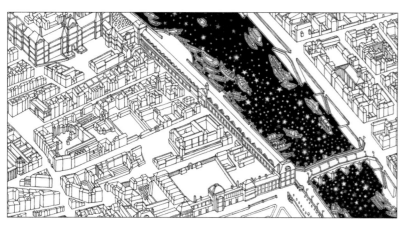

Plan de Turgot

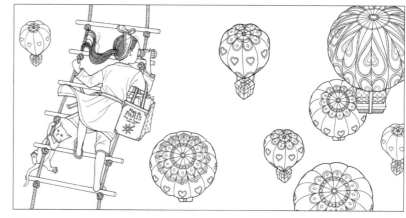

Where Is the Love

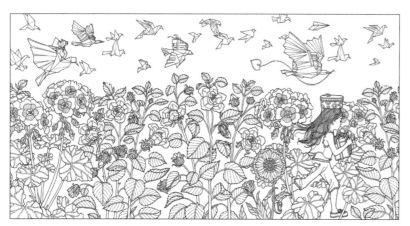

Chasing After the Wind

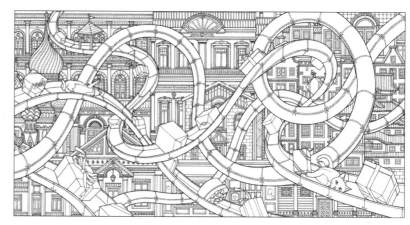

The Present Journey

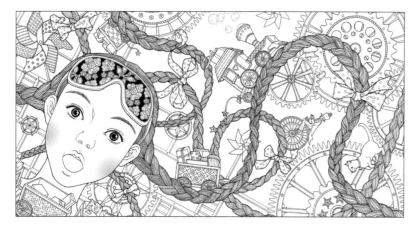

Crazy Braids

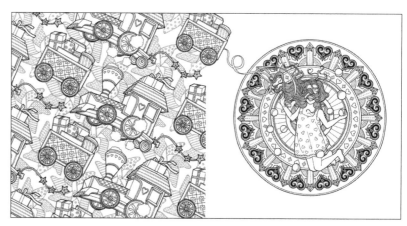

Merry-Go-Round

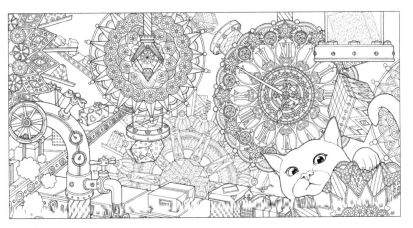

Popping Presents in the Clock Factory

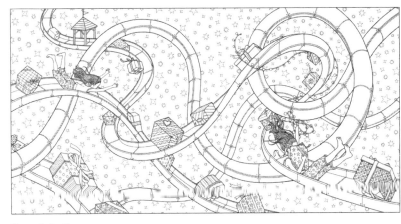

Spread the Joy

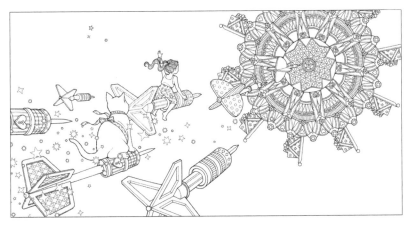

Arrows of Love

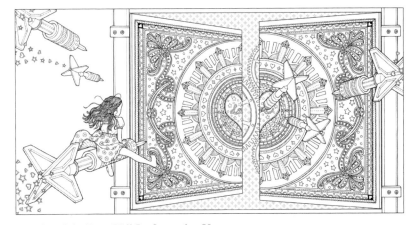

Knock and the Door Will Be Opened to You

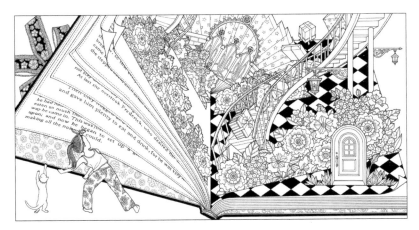

Pop-Up Wonders

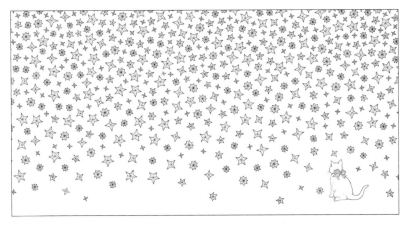

Wish Upon the Stars

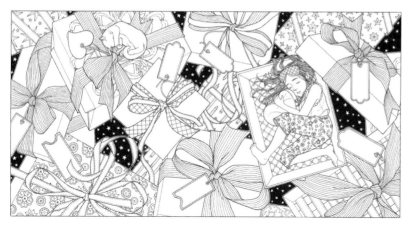

Sweet Dreams

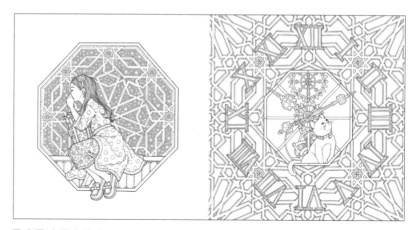

Tick Tock Tick Tock

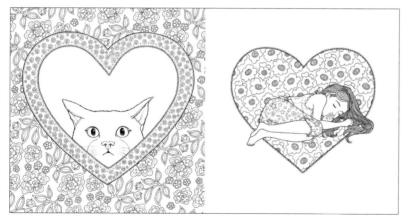

Heart You

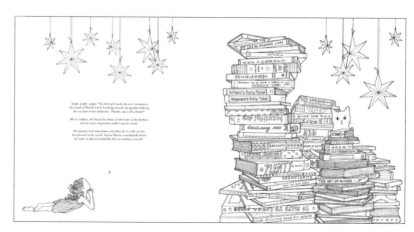

Book Pile

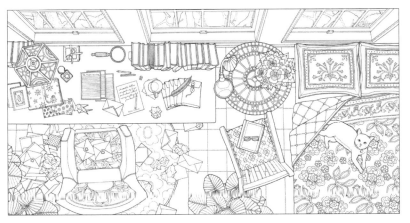

Sincerely Yours

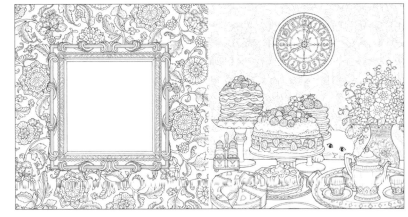

Birthday Breakfast

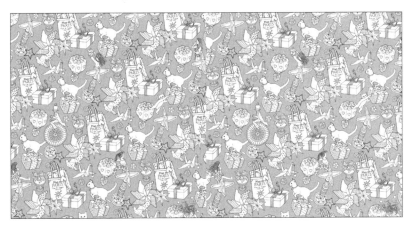

Wallpaper

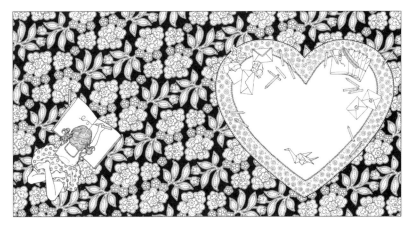

Doodle

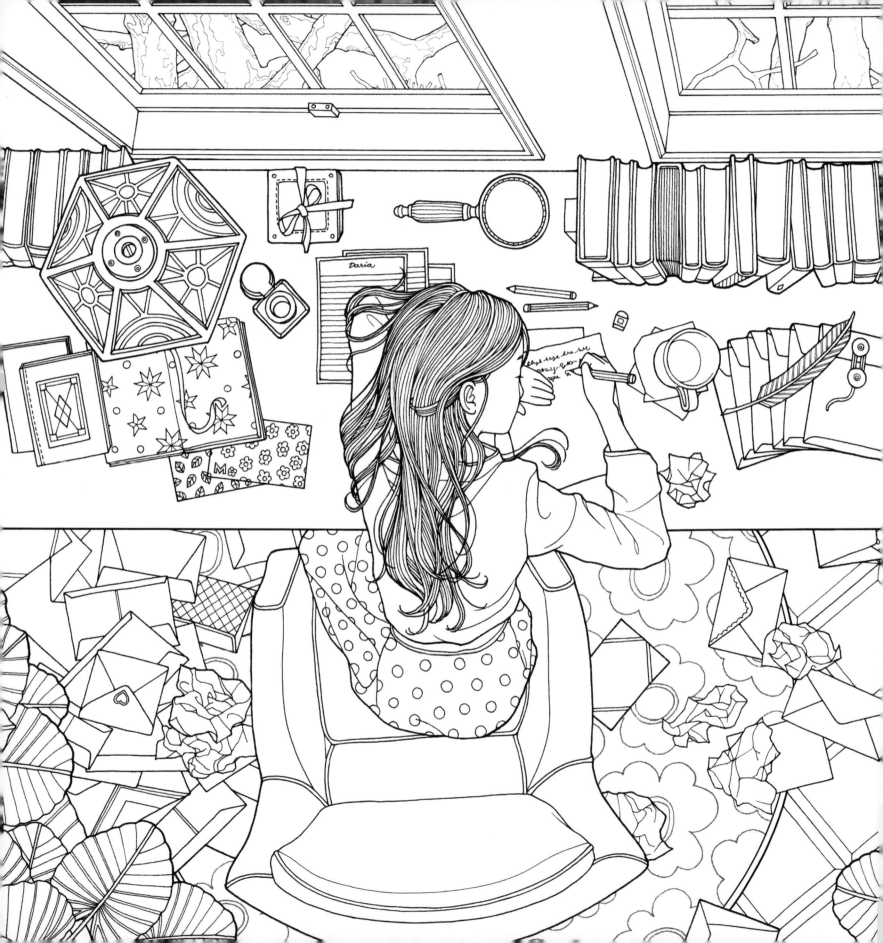

Cut-Out Card →

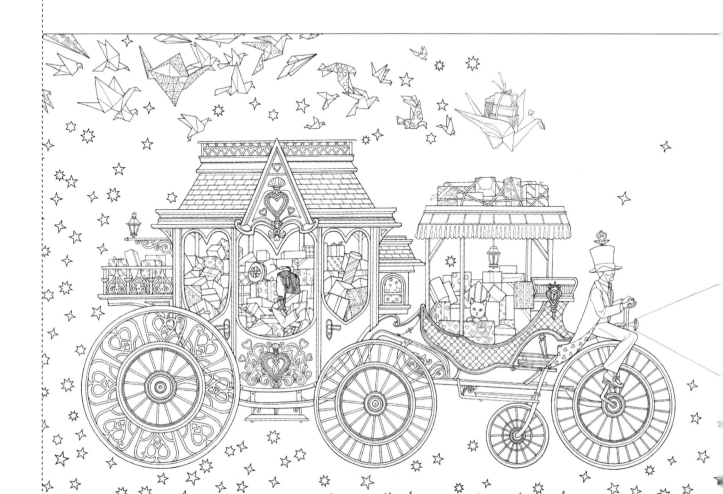